BIRDS OF A FEATHER

BIRDS OF A FEATHER

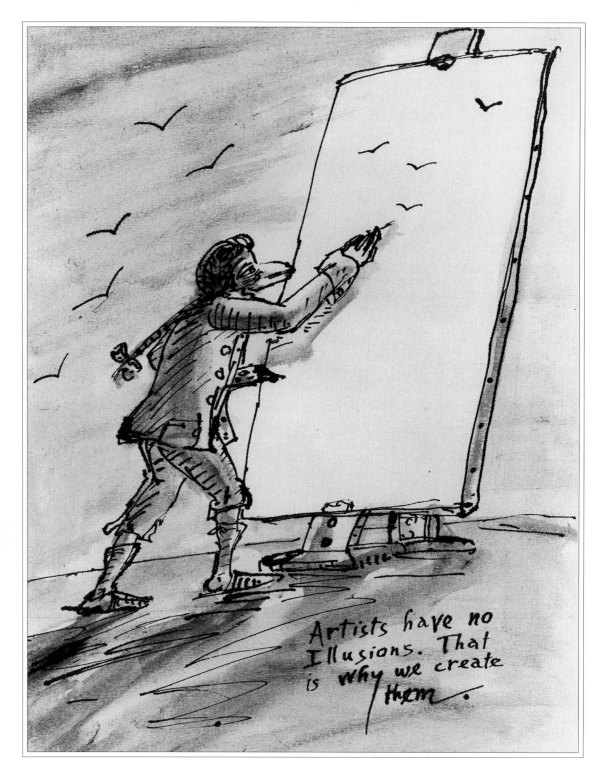

Artists Have No Illusions.
That Is Why We Create Them.

BIRDS OF A FEATHER

Philipp P. Fehl

Essay by Maurice E. Cope

Krannert Art Museum

University of Illinois at Urbana-Champaign

and

University of Illinois Press

Urbana and Chicago

Library of Congress Cataloging-in-Publication Data

Fehl, Philipp P.
 Birds of a feather/Philipp P. Fehl: essay by Maurice E. Cope: Krannert Art
Museum, University of Illinois at Urbana-Champaign.
 p. cm.
 ISBN 0-252-06241-8 (alk. paper)
 1. American wit and humor, Pictorial. I. Krannert Art Museum. II. Title
NC1429.F2955A4 1991
741.973—dc20 91.21514
 CIP

Contents

Foreword

IT IS WITH GREAT PLEASURE that we present this exhibition of Philipp Fehl's *capricci*. Over the years these marvelous excursions into wit, irony, and satire have delighted many. But it is to our public and Philipp Fehl's friends, colleagues, and students at the University of Illinois that his work is best known. Until his recent retirement, Professor Fehl's presence here provided frequent delights and inspiration in and out of the classroom. It is our hope that this publication will bring Fehl's drawings to the attention of the still wider audience they richly deserve.

The freshness, assurance, and sagacity of Fehl's art cause one to speculate about whether the clandestine motivation for a distinguished career in art history was the support of his efforts in the studio. Happily, I believe that in Fehl's nature, art and scholarship live in wedded bliss, two halves of a whole, and that the imaginative and immensely elegant view of history that informs his prodigious scholarly production also animates his pictorial vision. Perhaps a bridge of sorts can be discovered in Fehl's cultivation of the *capriccio*, from the sixteenth into the nineteenth century the artist's favorite playground of fantasy and surprise. However, in our era so charged with the bizarre and the unimaginable in both life and art, the playfulness of this genre can easily seem out of phase. Yet Fehl's drawings, with their eighteenth-century decor and friendly bow to Domenico Tiepolo, offer us something individual, enlightening, and, finally, encouraging. His jokes, after all, are expressed in an aesthetic language that is of our time. And they treat the questions, both large and small, that have always been part of a reflective existence. A smile eases the burden.

This publication and the exhibition it commemorates were made possible by a number of individuals. Foremost among them was the artist himself whose helpful presence made the project move easily. Special thanks are due to Maurice Cope for his perceptive catalogue essay. Linda Duke and Eunice Dauterman Maguire aided in the selection of images. Carol Bolton Betts edited the texts, and Kenneth Carls designed this handsome publication. Wayne Gibson and Harry Zanotti produced the photographs in it. Elizabeth Dulany and others at the University of Illinois Press were always generous with their interest and advice in the production and distribution of this book.

We are grateful to Dr. Paul Eisler for a special grant in support of the catalogue, and to the Illinois Arts Council for partial funding of the exhibition.

Stephen S. Prokopoff
Director
Krannert Art Museum

Acknowledgments

I DEDICATE THIS COLLECTION of *capricci* to Dr. Paul Eisler of London. Eisler is an inventor and rational engineer. Long before the German invasion of Austria, he left his native Vienna to find in England a place where his work would be appreciated.

At the time of the murderous persecution of the Jews of Central Europe that soon was to encompass almost the entire continent, Eisler put his inventor's skill, perseverance, and imagination single-mindedly to the purpose of helping people to flee. He discovered ways, each fashioned to suit a particular flight, to defeat the obstacles which bureaucracies on either side of the fence of death were erecting or, from their inherent lethargy, merely perpetuating, to keep the would-be refugees from crossing that barrier into safety.

Eisler was able to save seventeen lives, including my own.

He has long been a friend and supporter of my *capricci*. He encouraged me to make the selection which I here present in print. Eisler even invented a way to make his encouragement irresistible. My birds thank him for their new dress and I salute him in friendship, love, and gratitude.

I also wish to take this opportunity to thank Maurice Cope for his gallantry and wit in writing, as he does as an art historian, about the art of a fellow art historian who thinks of his life as a scholar, the illusions of circumstances notwithstanding, first and foremost as a condition of the life he leads as an artist.

I also thank Stephen Prokopoff, Director of the Krannert Art Museum, for his aid in mounting the exhibition, and I join him in thanking from the heart those at the museum and at the University of Illinois Press who helped to bring this book into existence and establish the form in which it meets its public.

P.P.F.
London
14.X.1990

Birds of a Feather: The *Capricci* of Philipp Fehl

THE TITLE IS THE ARTIST'S OWN, for the birds of his delightful *capricci* are all of the same feather, share the same feelings, and inhabit the same special world of hope and disappointment. The implications of this title are best shown by his own illustration of the same text, *Birds of a Feather Fly Together*, for the mailer for an exhibition some sixteen years ago. There are six scenes. In the first, five men, tied hand and foot, are hanged on the gallows. In the second scene, one has freed himself from the noose and sits on the cross beam, and in each successive scene another man frees himself; in the last scene all five have grown wings and fly away. The greatest meaning lies in the part of the title of this exhibition which is implied, not stated–that they will fly together. Their flying after escaping from a world in which they are all dying by strangulation is the life-enhancing joy of spiritual freedom which permeates Fehl's work.

More generally, the birds in Fehl's *capricci* are the images through which he can comment on the longings and petty desires, the tragedies and the mishaps, the profound beauties and the most transient prettinesses, the deepest joys and the most superficial amusements, both of mankind and of his own experience. He can do this with wit, or irony, or charm, or pathos, or any of a great variety of moods, as befits the subject. The odd thing about the dichotomies just mentioned is that in his art the humor often lies in collapsing the distinction between them. What starts out as grandly serious becomes lightly entertaining, and what seems trivial at first becomes imbued with all sorts of new and provocative meanings, and both ultimately become part of a search for Truth, all the more profound for not taking itself too seriously. The levels of meaning he can give the simplest observation make each work grow in us each time we see it anew. It reminds me of what one scholar said after listening to Fehl's comments about a Renaissance work of art: "The trouble with Philipp is that after he says something it takes you five minutes to understand just what it is that he has said." It is the same with his art–what seems at first a choice little germ of an idea will take seed in your mind and grow, both consciously and subconsciously, with ever greater meaning, until it flowers into something of unexpected beauty.

Why is a bird an appropriate emblem? Even though Fehl has sometimes denied the relationship between himself and the bird, the human bird manifestly is his alter ego, but an alter ego whom he can talk to and who, in quiet moments, can speak to him. As his art develops, his hero becomes more and more birdlike; the other animals he had once used disappear, and more and more birds fill his sky, with their poetic freedom from the bonds of the earth. The age-old association of birds with the soul, for they can take wing and soar, and the common identification of the eagle with intellect both reinforce the identification. One of Fehl's earliest

...images of birds

1

images of birds (fig. 1), a glass etching c. 1950, is remarkably human and mournful. In one of his later *capricci*, he depicts the transformation of a human profile into that of a bird (fig. 2). More striking, and surely unintentional, is the way in which his own face as he ages becomes more birdlike. Even from the beginning his bird mimicked his own magnificent beak of a nose,

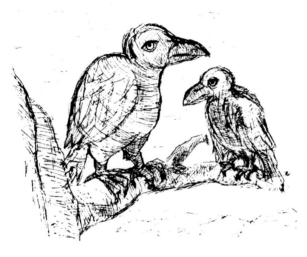

Figure 1.
Two Birds on a Branch
c. 1950
Glass etching

worthy of the Roman emperor Nerva, or of a disquisition in *Tristram Shandy*. But he must have known even then that the true bird is the old one. In a drawing of 1963 he shows a young academic walking beside an old, hunched colleague. The bird head is only on the old man, while the young one has something of a dog face. The bird is more than an image of the artist. It is used to show the trials and joys of all humankind. One is reminded of Plato's definition of Man (according to Diogenes): "Man is a biped without feathers." Like Plato's Man, Fehl's bird-man rarely flies, though he certainly must long to.

Philipp Fehl is a *rara avis* among artists in being an art historian as well as an artist, and in being distinguished in both callings. In both careers we see two sides of the same fowl, a bird of another period, fortunately not extinct, but certainly, like the noblest eagles, an endangered species. As an artist, Fehl takes as his model the *capricci* of Domenico Tiepolo, the most vivacious of eighteenth-century artists at the time of the first full flowering of comic sketches and caricatures. And as a teacher of drawing, in his early career at the University of Chicago, Fehl patterned a course on the work of the great eighteenth-century French critic, Diderot. It must have taken a certain *chutzpa* to do this at the time of the most innovative moment of Abstract Expressionism. But the parallel between his art and his teaching goes deeper than just this one course. It permeates his entire approach to art history. To stand with him before a Renaissance painting (or classical sculpture, or any such work of art), and to have him discuss it with you, is to let yourself be led into a way of looking and thinking completely alien to much twentieth-century thought. It is as if you were standing there with Diderot, or with Aretino, or with some very perceptive observer of the period, and thinking about it in his terms, not your own. Old concepts rejected or ignored by our age, like Beauty or Truth or the moral significance of the

work, find an easy and natural place in the discussion, as part of the deepest meaning of art, based on a profound understanding of how such art functions, and not at all the sort of cant of the nineteenth century which caused them to be rejected. In the same manner, Philipp Fehl can adopt the technique and to an extent the forms of the *capricci* of the eighteenth century and use them in a new way, never literally imitating them, but adapting them for his highly individual and personal insights. Just as his art could not exist without its earlier models, so too it could not exist without his unique personality and experience. He is just as individual and unique in his use of an earlier style as is T. S. Eliot in his use of the Metaphysical poets.

Fehl's art was not always so, and its changes come with a clear correlation to his experiences. He is Viennese, so Viennese an American, and American a Viennese. He was born in the city of Mahler and Freud and Schnitzler, of Schoenberg and Schnabel, of Klimt and Kokoschka and Schiele, of Werfel and Webern, in 1920, when all of them but Mahler and Schiele were still active there, and many of them Jewish, as he is. But he was not born into that artistic elite, far from it. His father was a shoemaker, proud of making "uppers," rather than the lower part, the sole, the less finely crafted part of the shoe. But Philipp nevertheless had a fine artistic education at the Kunsthistorisches Museum. From an early age, he delighted his mother with his drawings, which even then brought together what he had seen with what he had learned from his voracious reading. He was also fascinated by the American comic strips used as packing for the chocolates sent by his aunt in Chicago. They showed figures that could speak, and animals too. But when he tried to do the same thing in his drawing class in school, he was told, most firmly, that that was not art, and he had to promise, publicly, not to do such things again!

The crucial experience of Fehl's adolescence was the *Anschluss*, the German occupation of Austria, the furious persecution of the Jews, and the Holocaust. Many of his relatives were killed, and his immediate family was torn apart, his father going to Dachau, his mother catching the last ship out of Italy, his brother escaping to the United States, and Philipp himself fleeing

…to Czechoslovakia, having

to Czechoslovakia, having had to bribe a Nazi lawyer to secure a visa at the Czech consulate. It took quite a sum, which he got from his uncle, who had won it in a lottery. He continued drawing there, as a way of fixing images in his mind and of reconstructing from memory the life he had lost. He also wrote plays and very short stories, but he could keep nothing, for fear of being searched by the Germans who, by then, had taken over Czechoslovakia. In June 1939, just before the outbreak of the war, he escaped to England. He worked in Birmingham with a commercial printer who made movie posters. There he learned silkscreen making. Then in August 1940 he sailed for the United States. Miraculously, all members of his immediate family survived, and were reunited in Chicago at the home of his aunt.

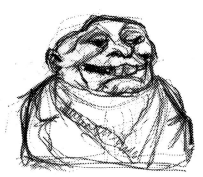

Figure 3.
Sketch from a Notebook
c. 1941

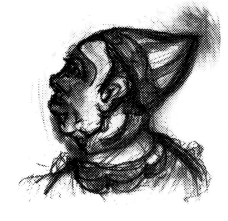

Figure 4.
Pierrot
From a notebook
c. 1941

It was extremely difficult for Philipp to find work in this country. He even sold pencils for a time. He then entered Herzl Junior College (it was all he could afford) for part-time and evening study. There the art teacher was impressed by the vehemence of his painting–expressionist before he had heard of expressionism–and she sent him to study at the School of the Art Institute of Chicago. His background courses in art history at the Art Institute were taught by none other than Helen Gardner, who turned her lecture notes into a book so popular that her name has been kept on it even after it has been totally rewritten several times by others. Although his approach to art history is entirely unlike hers, he must still be one of the most notable art historians she ever taught. His notebooks from his time at the Art Institute make fascinating reading. They include notes to himself about his early artistic enthusiasms: "George Grosz, Max Pechstein, Oskar Kokoschka–study Kokoschka," and in another place, in large letters, "Study Odillon [*sic*] Redon!" They also contain poetry he was moved by, and his own poetry. He copied out, complete, a poem by Rilke with its last stanza beginning, "In diesem Dorfe steht das letzte Haus / So einsam wie das letzte Haus der Welt." Fehl was very homesick for Vienna at that time.

Most of all, his notebooks contain innumerable sketches. He was very much of a European expressionist then, and these early drawings remind us of Nolde, Grosz, Daumier, and Rouault

4

(figs. 3 and 4). His recent memories of the Holocaust permeate the sheet (fig. 5) with satires of Prussian military types (lower left and upper right), a skull-like head inscribed "Homo Austriacus" (lower right), and a suffering man with sad, haunting eyes (upper left), inspired by Karl Kraus's play of 1917, *The Last Days of Mankind.* Such expressionist art was not well repre-

sented in American museums, other than in the Detroit Institute of Art and a few works in the Museum of Modern Art in New York and the Art Institute of Chicago. Peter Selz, who wrote the first substantial treatment of these artists in English, was later to be Fehl's fellow student at the University of Chicago. Fehl's violent expressionism, often crude, rough, and brutal, and always very serious even in caricatures, was not in keeping with the teaching of the Art Institute at all. He learned there not to trust his teachers and to pursue his own way, guided by the rich collections of the museum, including its fine collection of plaster casts of great sculpture of all periods. This was installed on either side of the ramp leading over the railroad

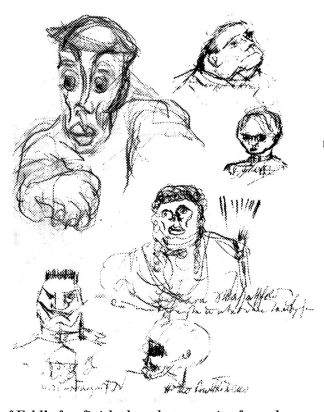

Figure 5.
Reflections on Karl Kraus's
LAST DAYS OF MANKIND
From a notebook
c. 1941

tracks to the back part of the museum. One of Fehl's few finished works to survive from that period is his Redon-like silkscreen of a head, disembodied and hauntingly floating above the earth (fig. 6). A much more expressionistic drawing of this same mournful head has three cannon and two threatening heads rising from the bottom left of the picture and a delicately drawn flower in the center.

Later that same year (1942) Fehl was drafted into the army, having already applied for United States citizenship, which was granted in 1943. It was the army that saved him, he said. After basic training and a short stint in the coast artillery defending California from attack, he was sent to Stanford University in a foreign-language program, and then assigned to France in the Eighty-ninth Division. But instead of going there, he was sent to Camp Butner in North Carolina as an M.P. to watch over the German prisoners of war. There he met his future wife,

...Raina, who, like Philipp

5

Raina, who, like Philipp, is Viennese, like Philipp had fled to the United States via Holland and England, and like Philipp had joined the U.S. Army. It was a perfect match! He continued his art work in the army, on off-hours, and rather secretly. He even kept a small silkscreen press in his duffel bag. His work was still expressionistic, but included more narrative drawings, and

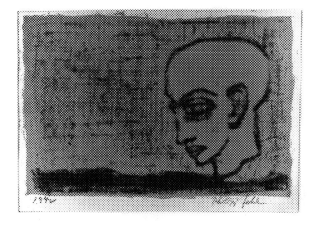

prints done in series. One of these was a group of serigraphs appended to the text of the epilogue to Karl Kraus's play, which he sent as a mordant holiday card in 1944, with a woodcut cover bearing a plaintive inscription, "Fiat lux" (let there be light) (fig. 7). Then with the ending of the war, he rebelled against the violence of his earlier work, which he found almost pompously Germanic, and strove instead for more modesty and a much finer drawing style. He discovered the eighteenth century and Blake and then Reynolds.

After his discharge from the army, his former colonel invited him to help with the Nuremberg war crimes trials. Fehl discussed the matter with his father-in-law, a legal scholar who had suffered horribly under the Nazis and who hated their atrocities as much as anyone. However, his father-in-law had great misgivings about the legal basis for trials conducted by the victors in a war on the basis of *ex post facto* laws. For him the law itself was sacred, and he advised against participating in the trials. Nevertheless, Philipp did accept a position as an interrogator, though he had no legal experience. Perhaps the irony of a Viennese Jew becoming an American and helping with the trials of his persecutors was not lost on him. A place was found for Raina, too, as a research analyst. This was to become the pattern of their lives, for she has continued to help him with his research to this day. A quarter of a century later he wrote most movingly and perceptively of his experiences during the trials in an *Atlantic Monthly* article entitled "The Ghosts of Nuremberg." In it he mentioned how Hermann Goering, who prided himself on not hating Jews, asked him to convey his greetings to one of the Jewish owners of the *New York Times*. (Such greetings, of course, were never delivered.) Fehl's eye for the grotesque and ironical detail, whether it be the foolish pride of the accused or the posturing of the judges, never deserted him. Philipp and Raina were appalled by the inadequacy of the trials and the bureaucracy to the crimes they were addressing. After a year they "practically fled," he said,

"because we realized that we were becoming part of a machine which more and more was working routinely, registering deeds of horror in terms of its own inane momentum only."

After the war Fehl returned to Stanford for his B.A. in Romance Languages and his M.A. in Art History. At the University of Chicago he began his work for the Ph.D. in the art department, but soon switched to the Committee on Social Thought. As an art historian he was more of an observer and commentator, whereas before as an artist he had been totally involved himself. He continued the study and practice of an artist, while studying languages and the history of art, but his art underwent a startling change. It acquired a certain distance, and it gained the wit and

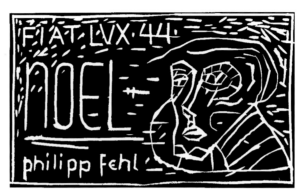

Figure 7.
Cover of Christmas Booklet
1944
Woodcut

humor that can only come with that distance and some objectivity. But that did not mean any loss of emotion. It only meant that the idea, if presented humorously, could cut all the deeper, as he himself has said. It also meant that a much greater emotional range had opened up for his art, a much greater variety of themes, and a much more varied response to them. His new art became an amalgam of many more facets of his being. The visual side continued, of course, but it now incorporated his literary side in the title or inscription, which made the meaning more pointed. And the poetic side found the words and moods to express itself. Indeed, he created a new and highly individual "artistic personality"–a bemused commentator, who sees the comic side of each of life's little joys and petty disappointments. His voice is so clear that we immediately recognize it in the words of any new title. But the words without the picture would be incomplete. The lightness of his sketched line, the unpretentiousness of his manner, keep us from taking too seriously the words, though they often imply levels of deeper and more serious meaning. His *capricci* also mirror his own life. He usually spends some time each day with them, and so has built up a sort of personal diary, not of the events of his life, but of his thoughts. Occasionally they may refer to specific events, but more often they are of more general significance. When they are derived from some specific happening, they are still put in such general terms that they require no outside explanation. For his own reference he may add the date of the event that gave rise to that particular drawing. One such dated work (see page 27) depicts a lone bird-man standing on top of some immensely tall stilts and looking at distant hills. It is

...entitled The View, When

7

entitled *The View, When There Is Nothing to Say*, and surely must be a memento of an excruciatingly dull party.

In yet another way these *capricci* unite the two main sides of Fehl's career. They are works of art with a specific art-historical reference, the eighteenth-century caprice of Domenico Tiepolo and such artists. Of course he is quite conscious of this relationship. As an art historian, he has put together an exhibition and catalogue of the history of the caprice in art–many of his notable predecessors. That provides the perfect context in which to see his own work as an artist.

It was in the art collection at Stanford that he first discovered the *capricci* of Domenico Tiepolo, which became so important a basis for his new form of art. However, in no sense does he imitate that eighteenth-century master. Rather, he takes from him only the general concept of an amusing and thought-provoking sketch. Tiepolo uses the figures of the *commedia dell'arte*, primarily Punchinello, for the figures in his sketches, and there is in Fehl's work some of the spirit of the *commedia dell'arte*. But there is no Punchinello. Instead, he puts his bird-man in eighteenth-century dress–tight breeches, short coat, and a pigtail with a ribbon. This is a sort of elegant and graceful bow of appreciation to his eighteenth-century master. It also removes the character from the realm of present-day reality to that of fantasy, and so keeps the message, often intimately tied with present problems, from being too heavy and serious.

Another source for Fehl's *capricci* is the American comic strip he knew as a child. This, in turn, comes from the work of Rodolphe Toepffer (1799-1849), the Swiss creator of the comic strip, or, in his words, the "picture story." These were amusing anecdotes (with moralized messages) of Toepffer's walking tours of the Alps, or the *voyages en zigzag*, with his pupils in

Figure 8.
Season's Greetings
1954
Duplicated cash
register roll

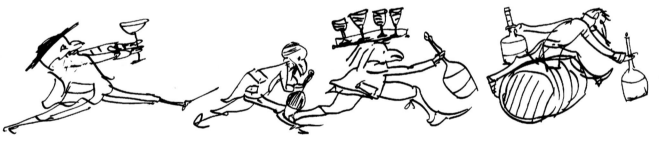

the boarding school he ran. Though originally written for those who participated in the tours, they were later published and came to be much beloved by Swiss children. They were illustrated by many drawings, some carefully drawn, but most very loose line drawings, without color or shading, as if by an untrained artist, although in fact Toepffer was trained by his artist-father.

He wrote an "Essay on Physiognomy" in which he advocated this form of drawing, with free and discontinuous lines, and the exaggeration which comes naturally to them, to create a sense of the character or soul of the figure. He then discussed how character can be shown by the simplest forms of the chin, lips, nose, eyes, the shape of the head, and the posture. As an art historian, Fehl has written most sympathetically about Toepffer, his drawing and his theory, and as an artist he has wittily illustrated the text with his own drawings. But the greatest tribute he pays him is in his own *capricci*.

It was at the University of Chicago that I first met Philipp Fehl. We were both working on our doctorates, but he was a few years ahead of me in age and in his work on the degree, and far more than a few years ahead of me imaginatively. What were we earnest Midwestern students to make of this Viennese poet? He was full of ideas, many of them new to us, and most of them cast in forms quite apart from our more conventional way of thinking. Yet he was certainly the most interesting and provocative of our group, and the most witty and entertaining, too. Our departmental faculty was very heavy with German refugees who had fled at various earlier times from Hitler. With each class we had to master a totally different version of English, though this no doubt was less a problem for Philipp than it was for me. Ulrich Middeldorf, a great connoisseur of Italian sculpture and a bibliophile par excellence, had been the librarian at the Kunsthistorisches Institut in Florence and was to return there as director. At Chicago he was department chairman. He seemed to have read everything in all fields. He had been the mentor of Allen Weller, when he wrote his dissertation on Francesco di Giorgio. Ludwig Bachofer was our orientalist, a pupil of Wölfflin. His distinction was in applying Wölfflinian categories to the study of oriental art! It was quite surprising to see how well they worked, but nothing could be

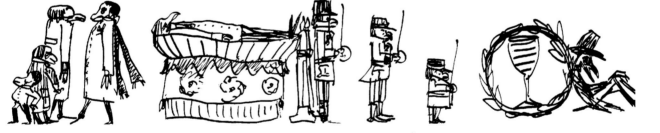

(continued)
→

further from Fehl's approach. Indeed, Fehl had gone into art history to improve himself as an artist. He hoped to find there the literary background and the values that were so wanting in the world of twentieth-century artists. But he did not find those values in academic art history either. However, there was yet another option, the Committee on Social Thought. Otto von

...Simson (who always wanted

9

Simson (who always wanted to be called simply "Mr. Simson" in this country) in medieval art and P. H. von Blanckenhagen (who was never mentioned without the "von") in classical art had appointments in the Committee on Social Thought, but both taught regularly in the art department. Von Blanckenhagen was a complex man who could be, by turns, very helpful or very cruel. At our Christmas party in Lorado Taft's studio, which we decorated with our caricatures of art-historical catchwords, von Blanckenhagen searched in vain for some nasty representation of his hunched back and then pronounced his judgment on us: "The trouble vif you students is that you haf no taste for punitive satire." During his seminars he personally polished each three-by-four-inch slide before presenting it, and spoke so brilliantly that a recent *New York Times* article described it as making you want to cry. For him the importance of the work of art was what it could teach us, and he specialized in ancient art because he thought that the philosophy it embodied could teach us the most. It was in this committee that Fehl found his proper place, for this group fostered a much broader cultural approach to art history and was more sympathetic to new ways of approaching the discipline and the search for values so important to his way of thinking. He wrote his dissertation under von Blanckenhagen. Fehl became so close to the chairman (and patron) of the committee, John U. Nef, that Nef later asked him to edit a memorial volume of the writings of his wife, Elinor Castle Nef.

Fehl's first position after leaving the University of Chicago was at the University of Kansas City. It was there, ironically enough, that he began his international career as an art historian. He wrote a letter to Ernst Gombrich at the Warburg Institute in London about a problem connected with one of his writings, and, of course, wrote it in the poetic manner natural to him. Gombrich, reading this, thought he had discovered a singular talent hidden in the hinterlands

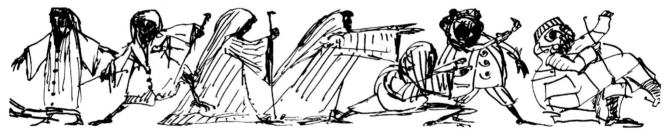

of Middle America, and so he helped him to secure a research fellowship at the Warburg. Only later did he discover that his cultured man of Missouri was really from Vienna. From there Fehl went on to long-term appointments at the Universities of Nebraska, North Carolina, and Illinois, and short-term appointments at Berkeley, Brown, and Tel Aviv. He has been a regular at

the American Academy in Rome for many years, and is now settled in Rome, semipermanently. No conference on Venetian art of the sixteenth century or on Bernini would be complete without his participation, and often his contributions have been the most memorable parts of the meetings. The wealth of original ideas which was so startling (and at times upsetting) to his fellow graduate students and teachers has come to be supported by a greater depth of scholarship, and so has been much more fully accepted. As he has learned from the great men in the field of scholarship, but has never lost the freshness of his poetic insight, so the field as a whole has learned to see works of art through his eyes and mind, and is all the richer for it. Indeed, he has at times completely reversed the general interpretation of an artist, as with Veronese, so that we can no longer look at his paintings as merely superficial decorations rather than as serious and even profound religious images. The range of Fehl's scholarship has been astonishing: from the Parthenon through Raphael, Titian, Bernini, and Canova, to Turner and even to Harriet Hosmer, the American sculptor of the nineteenth century in Rome, whom he can admire as a true artist, not merely because she was a female artist.

Fehl does not shrink from challenges, even the most daunting, in his approach to art history. The best example of this is his series of twelve broadcasts entitled "Art and the Imagination: An Introduction to the Poetry of Renaissance Painting for the Particular Pleasure of the Blind." These date from only four years ago. Many people have produced films or television programs about art, but who else has done it with words only and done it expressly for the blind? This is carrying Horace's famous words *ut pictura poesis* to their logical (or illogical) ultimate extreme.

Through all this scholarly and academic work, Fehl's artistic career has not been pushed

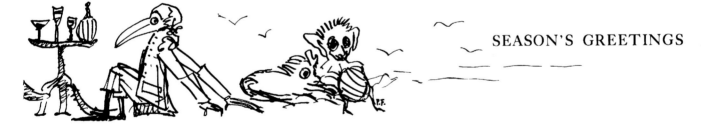

SEASON'S GREETINGS

to the side. He continued to study painting and graphic arts concurrently with his study of art history, and he earned a teaching certificate in art in the state of Illinois, which he put to good use in various positions teaching studio art early in his career. More important, he still works for a time almost every day at it, and is very rigorous about which of his sketches he preserves.

But they are all part

11

But they are all part of him. That accounts for the poignancy of his *capriccio* entitled *Saying Good-bye to a Mediocre Drawing* (page 110), showing his bird-man sadly depositing it in a grave. He has exhibited his works widely, in Austria, Germany, and Italy, as well as in many places in the United States, and he has published them in many journals and in two substantial volumes.

The *capricci* vary in form and subject. Most are single sheets, as are all of those in the plates of this catalogue, and most are approximately eighteen by twenty-four inches in size. But when Fehl was a graduate student he started putting groups of them together in the form of stapled booklets. This, indeed, he had already done with some of his prints in the heavy, expressionistic style of his Art Institute days. Some of his *capricci* are very much occasional, and drawn on anything that came to hand. There is one beautiful group of the four seasons, drawn in colored pens (one of his rare uses of color) on the inside of a record album of Vivaldi's famous set of four concerti of that name. Also while a graduate student he devised an original form for continuous narrative. He took great rolls of cash register tape (at a time when that tape was much more sturdy that it is now) and drew continuous narratives from left to right, in many scenes but with no dividing lines, and extending as much as a yard. These are totally without words. A few are mordant tales, but most are quite charming. Some give in brief an entire life history. Some of these he duplicated in sections taped together and sent out as holiday greeting cards to his fortunate friends (fig. 8).

There have been slight changes in manner over the last forty-odd years Fehl has been making these drawings, as his hand has become bolder and his eye sharper. But it would be a mistake to try to make any historical progression. He has purposely left them undated (except for a few that commemorate special occasions), to frustrate any would-be chronological analysis of style. He is, being an artist, a most antihistorical historian.

Seldom is there anything in the *capricci* which connects with events in the outside world. Rather their subjects are the universal and timeless. Some are age-old themes in art and literature: the four seasons, Arcadia and the discovery of death even there (the tombstone inscribed *Et in Arcadia ego*). Others are more topical: the trauma of a tenure decision, the effect of malpractice suits on doctors' treatment of patients. A few also are gentle satires on the foibles of art historians. One of the most delightful of these is his *Death of Neo-Plato* (see page 62). The professors mourning their dying hero are, of course, those numerous scholars who find in Renaissance Neo-Platonism a system so general that they can apply it to virtually any work of

art and produce an elaborate allegorical interpretation. Their lament, "non morir, Neo-Plato, non morir," he took from Monteverdi's *L'Incoronazione di Poppea*, where there is a similar lament for the dying Seneca, which Fehl sees as comic too. He has drawn several *capricci* (such as *The Dreams of Reason and the Dreams of Pedantry Beget Monsters*) which depend on Goya's famous *capricho* 43 (*The Dream of Reason Begets Monsters*). This depicts birds and bats descending on an eighteenth-century man whose head is buried in his arms. This Goya print, which Fehl first discovered at Stanford, in a way stands behind the whole body of his work. Fehl's most persistent theme, however, is quite different. It is the hopeful struggle toward something higher, no matter how drab one's situation may be. He can express the contingency underlying any progress we may make more poignantly by adding a single word, such as "perhaps," than can others in a long disquisition. What is important in all of his *capricci*, as in the philosophy of von Blankenhagen, is what they teach us—what they teach us about life, about human nature, about nobility of spirit, about Beauty and Truth, and, with that, about the Goodness of Mankind. He expressed it best himself, speaking in the third person in a catalogue entry: "His *capricci* most often represent birds in human dress performing superhuman actions in an atmosphere of lyrical regret and, often, sly mirth or slapstick. . . . They offer him and his patrons a life-enhancing access to truth and poetical consolation in the vagaries of being alive."

Maurice E. Cope
University of Delaware

MY BIRDS ARE ALWAYS IN FLIGHT, even when they sit down and talk to each other. They live in a world of gray washes. In their flights they seek and find or go home to a curiously qualified eternal rest. They have been with me since childhood, they grew up with me and are infinitely wiser and more seasoned in their ways than I can ever hope to be, no matter how long I live. They offer comfort, consolation, and the wry kind of hope that only pessimists possess and, in reticent charity, perhaps out of a sense of loneliness allied to duty, are willing to share. Their own support in life is a joke, uttered at the right time, in the right accents.

As an artist I am in essence a bird-watcher and the birds' historian. I write down what they say as they rise from or fly off into the darkness of their ink washes. We know each other and together have made friends in odd and lovely places, way stations in our flights. We sometimes flee—when we are bored to death or when the birdcatchers are after us. When push comes to shove and often just for the exercise, we fly. It usually rains in our world. We are glad that we know each other and we have come to depend upon each other.

Where would we be, gentle viewers, you and I and the birds, if the *capriccio*, streetwise and generous, did not stealthily pick the lock on the gate that opens to the world where the gray washes turn into light?

I.
SEASONS

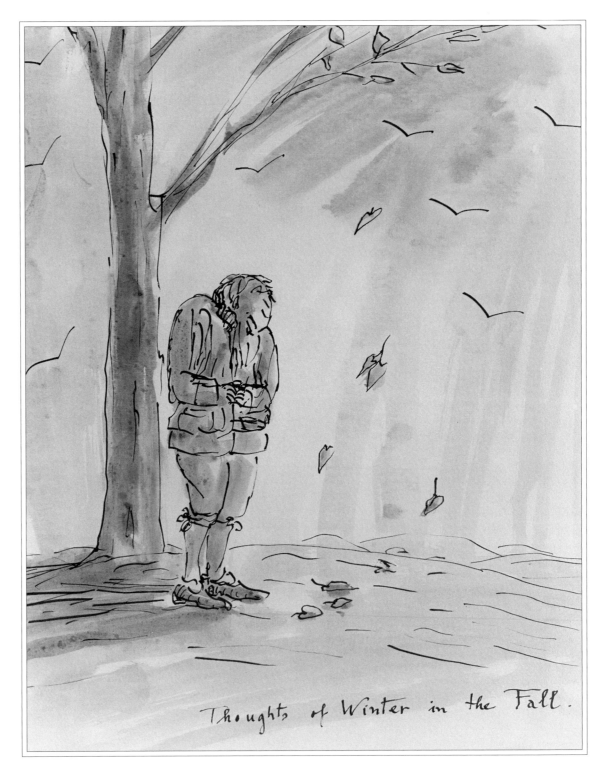

Thoughts of Winter in the Fall

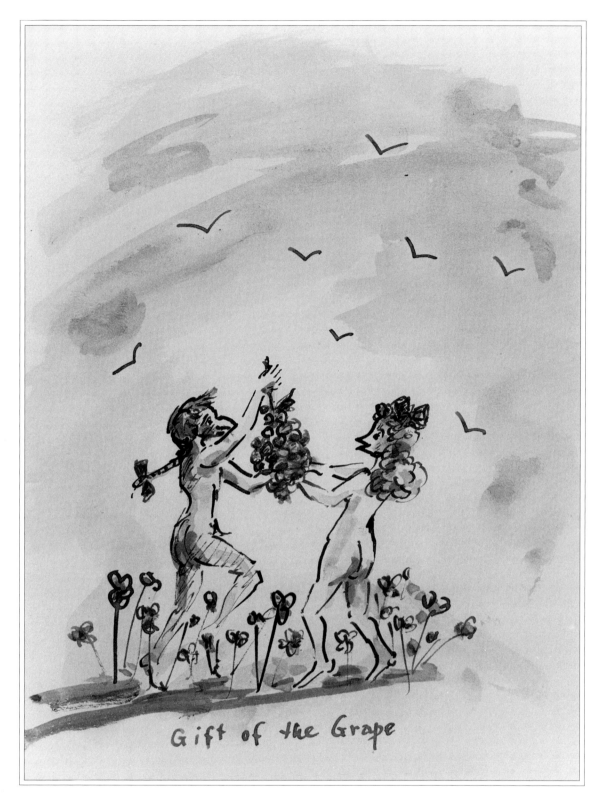

Gift of the Grape

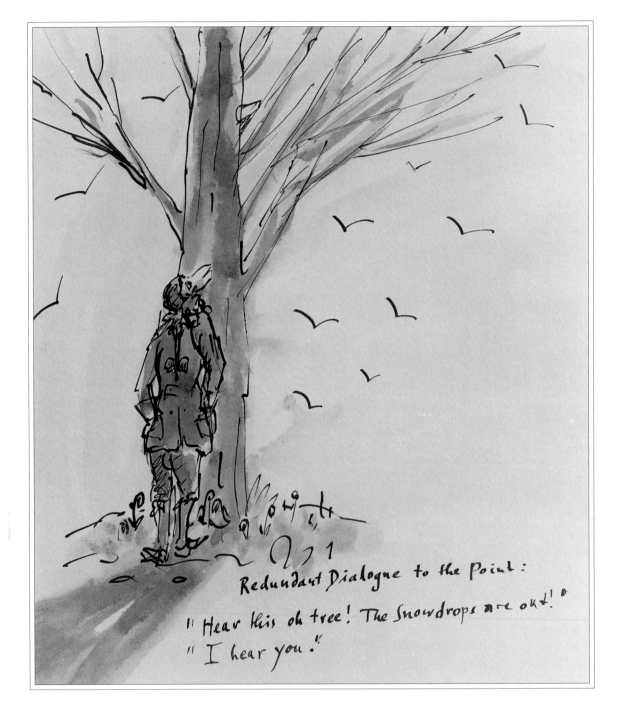

Redundant Dialogue to the Point:
"Hear this oh tree! The Snowdrops are out!"
"I hear you."

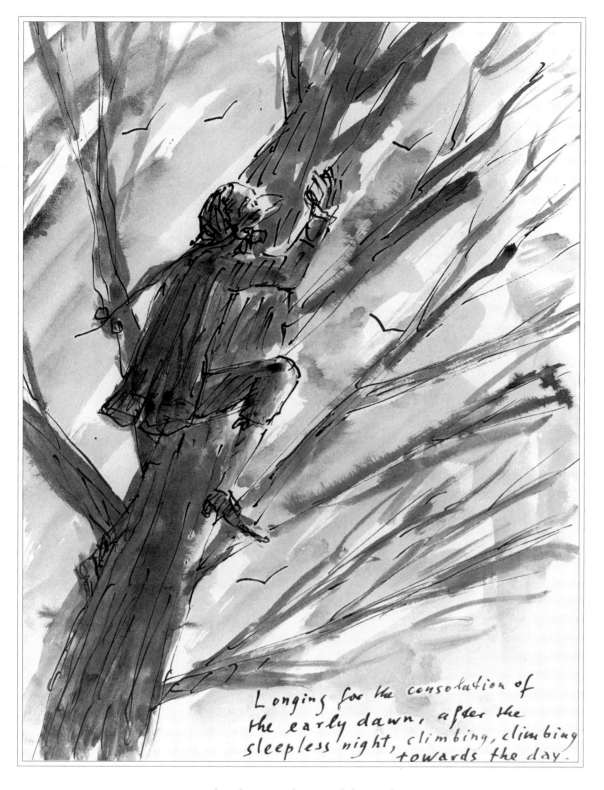

Longing for the Consolation of the Early Dawn,
after the Sleepless Night,
Climbing, Climbing towards the Day

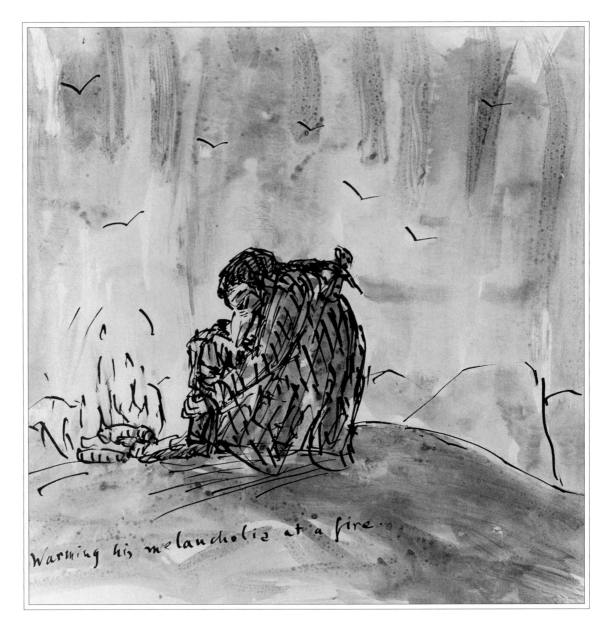

Warming His Melancholia at a Fire

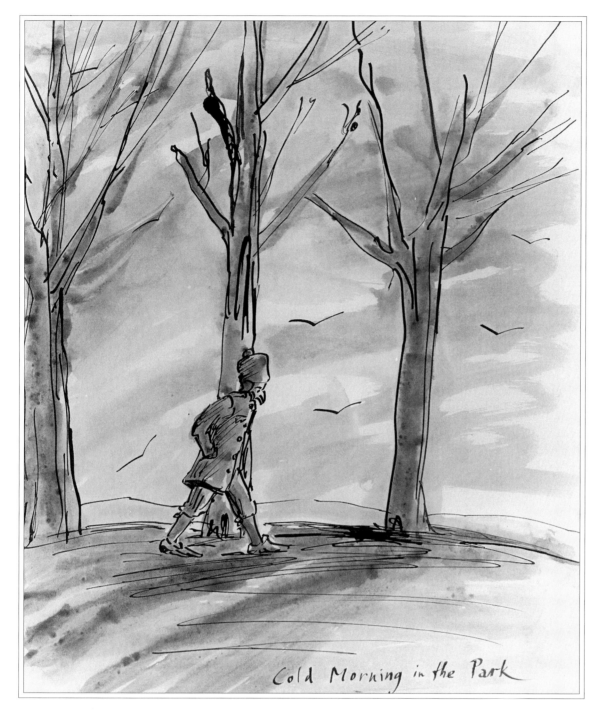

Cold Morning in the Park

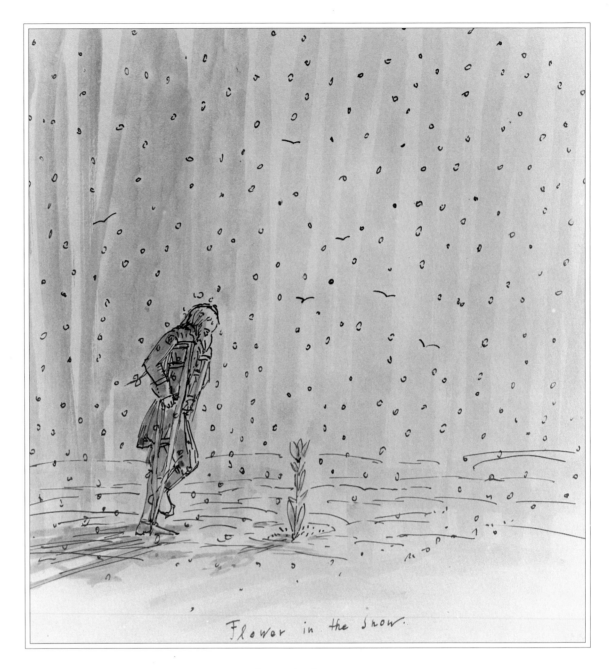

Flower in the Snow

II.
FACTS OF LIFE

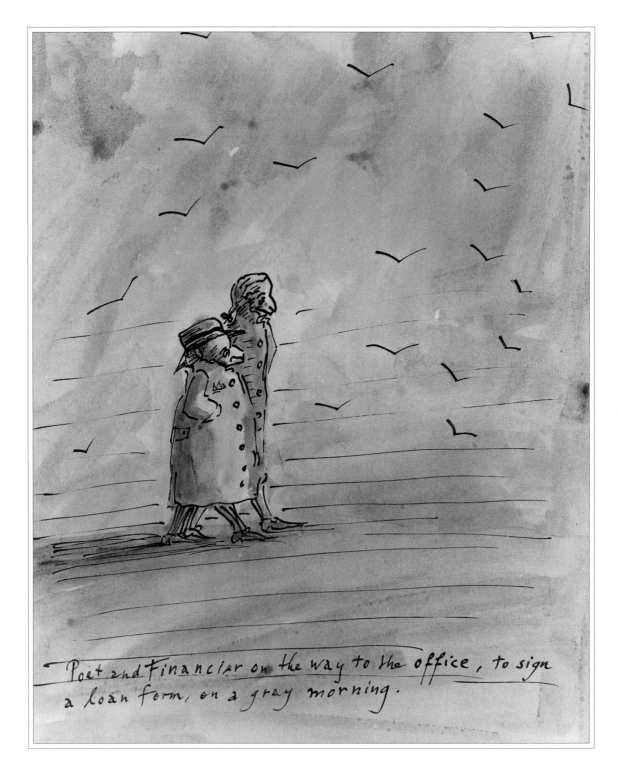

Poet and Financier
on the Way to the Office, to Sign a Loan Form, on
a Gray Morning

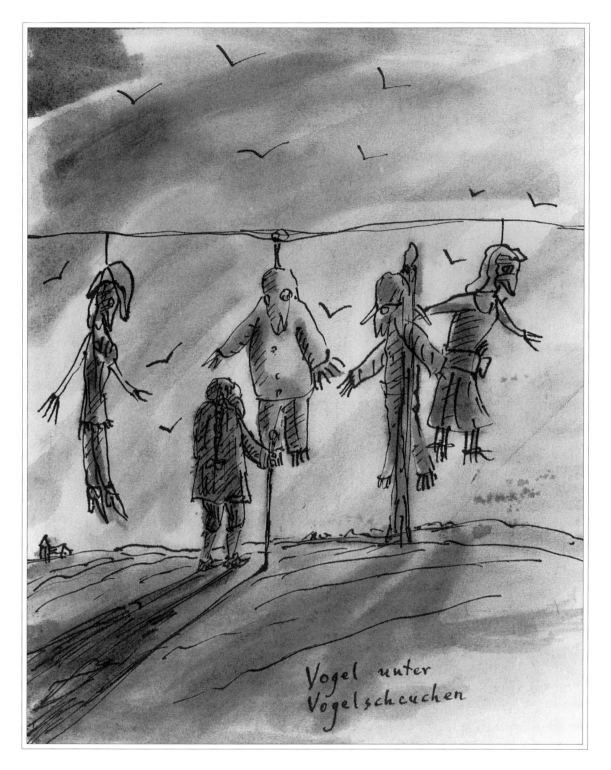

Vogel unter Vogelscheuchen

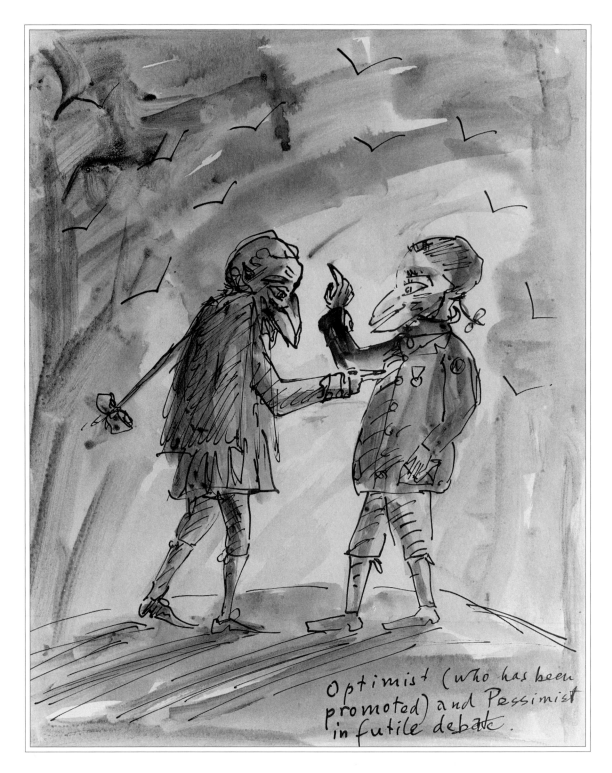

Optimist (Who Has Been Promoted)
and Pessimist in Futile Debate

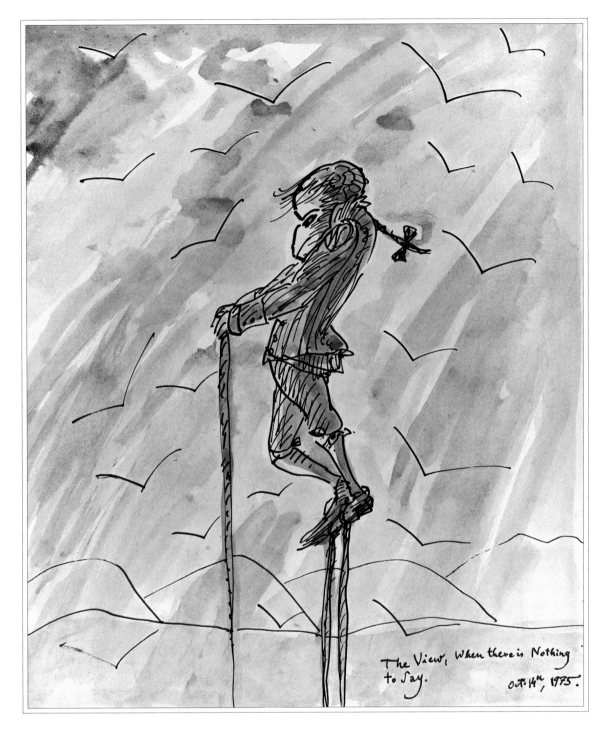

The View, When There Is Nothing to Say

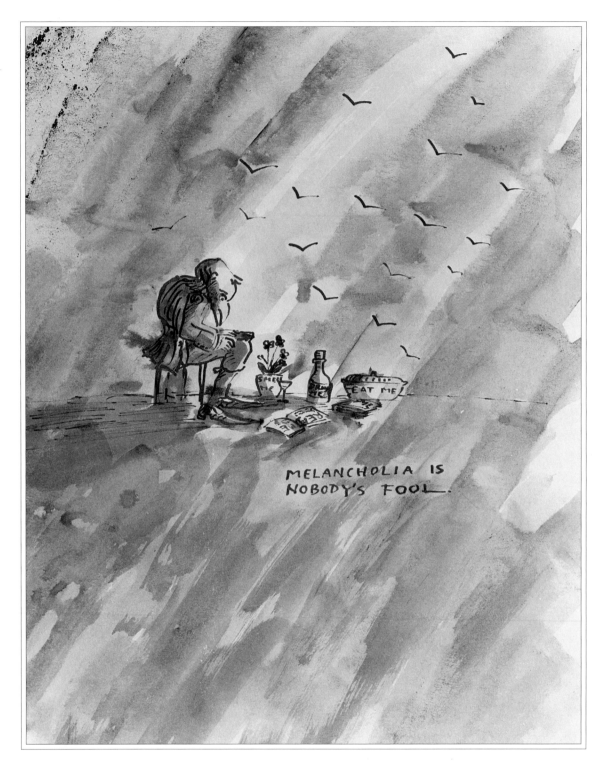

Melancholia Is Nobody's Fool

III.

DOCTORS AND PATIENTS

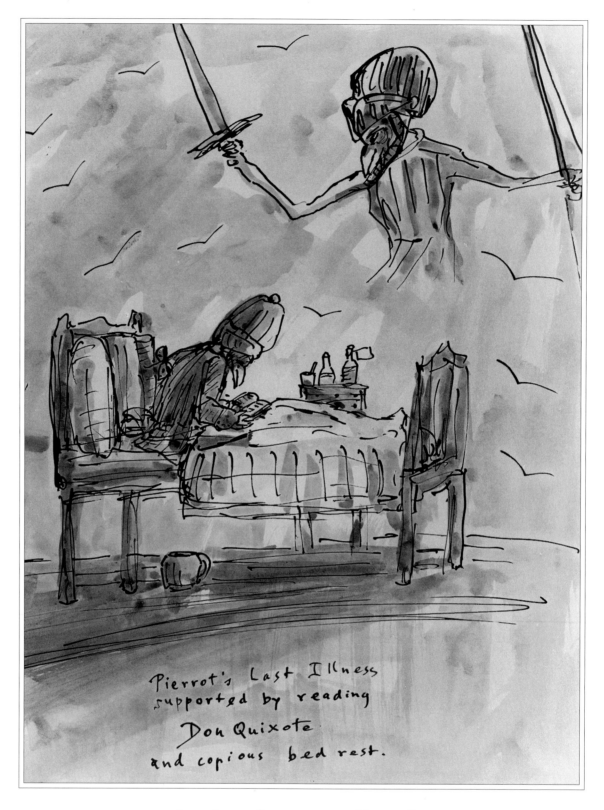

Pierrot's Last Illness, Supported by Reading
Don Quixote and Copious Bed Rest

"Just a simple incision!"
(State of the Art before the Discovery of Malpractice Suits)

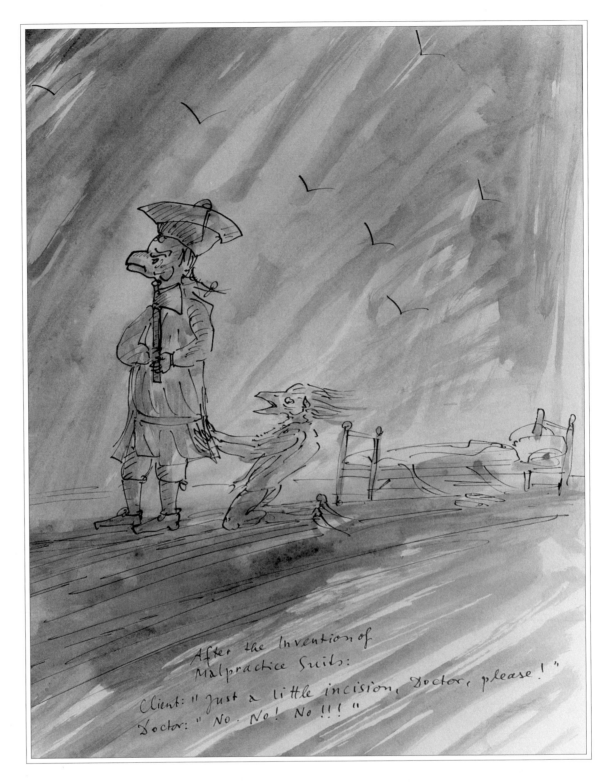

After the Invention of Malpractice Suits:
Client: "Just a little incision, Doctor, please!"
Doctor: "No. No! No!!!"

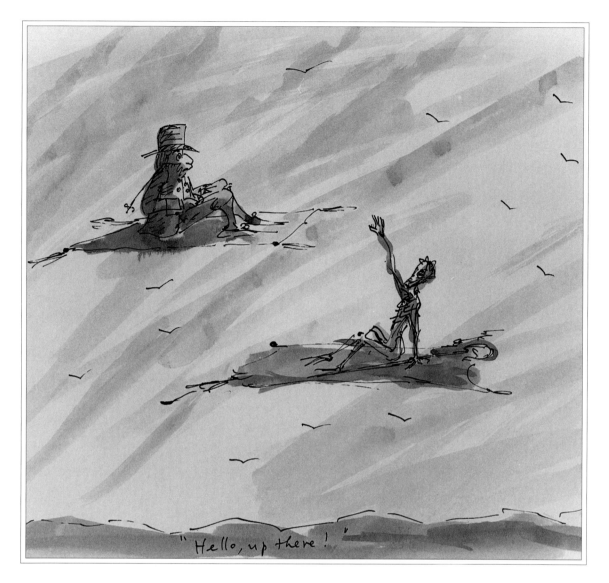

"Hello, up there!"

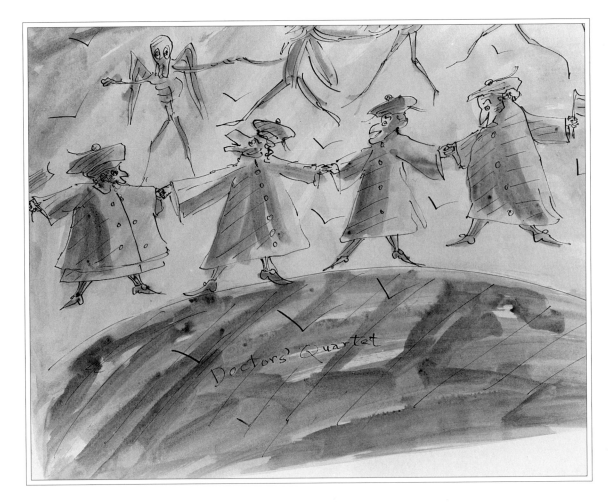

Doctors' Quartet

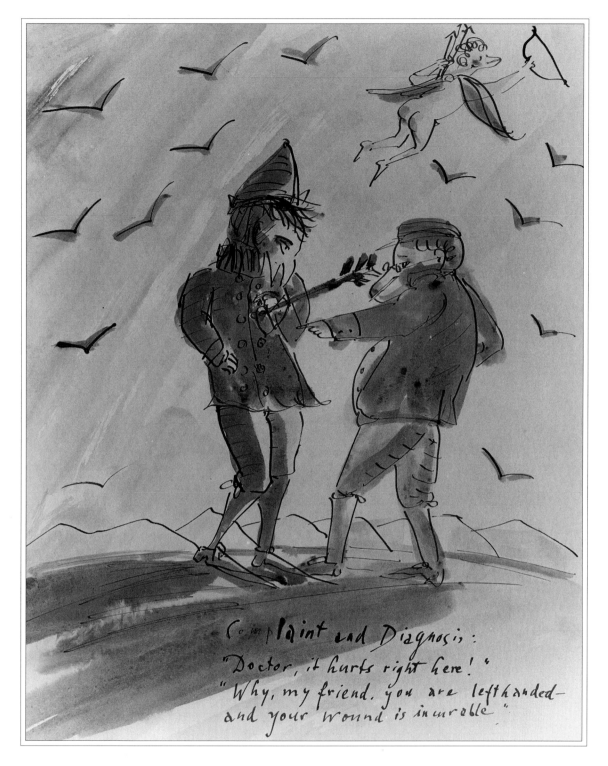

Complaint and Diagnosis:
"Doctor, it hurts right here!"
"why, my friend, you are lefthanded–and your wound is incurable."

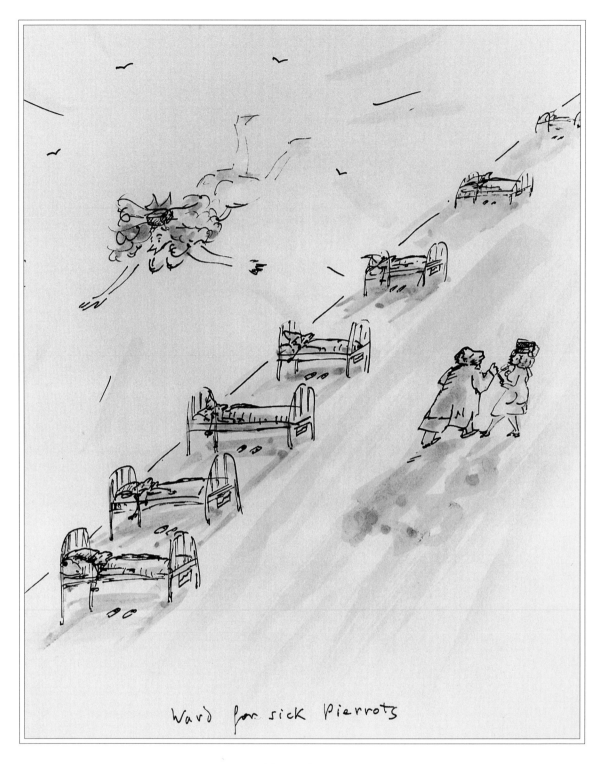

ward for Sick Pierrots

IV.
ARCADIAN VISTAS

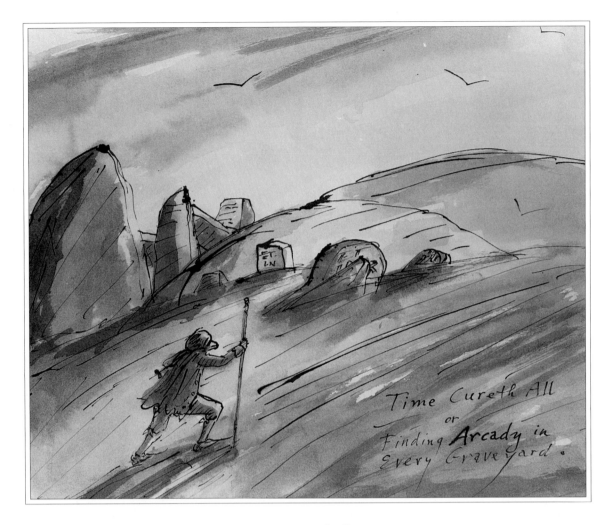

Time Cureth All
or
Finding Arcady in Every Graveyard

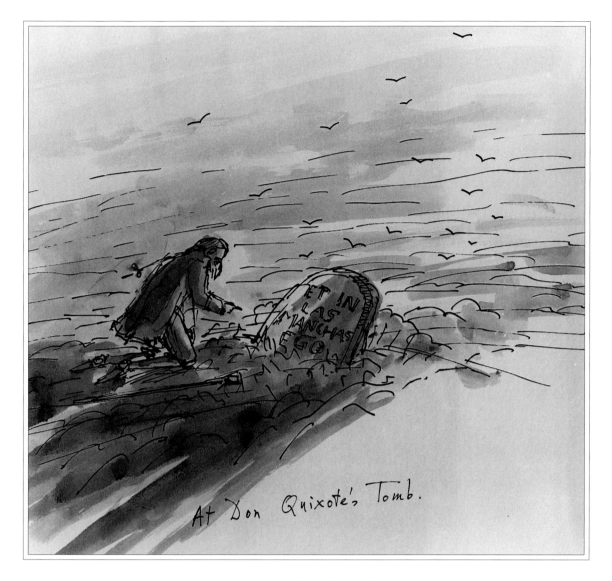

At Don Quixote's Tomb

Cemetery in Arcadia with Ghosts Playing Mora

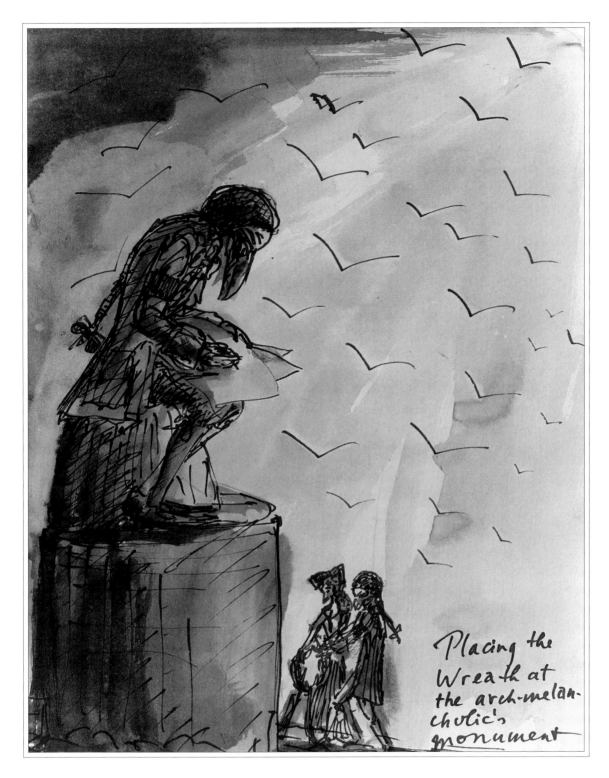

Placing the Wreath at the Arch-melancholic's Monument

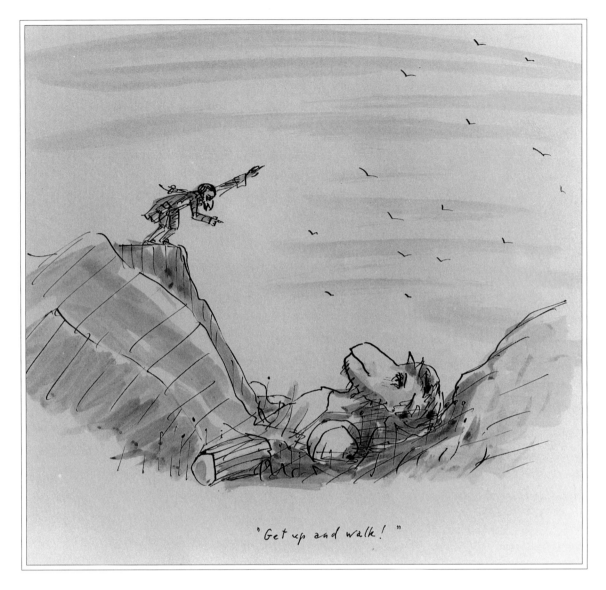

"Get up and walk!"

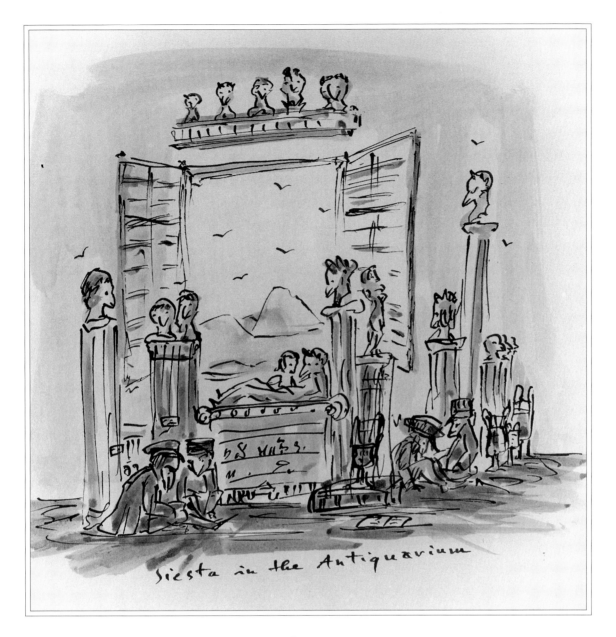

Siesta in the Antiquarium

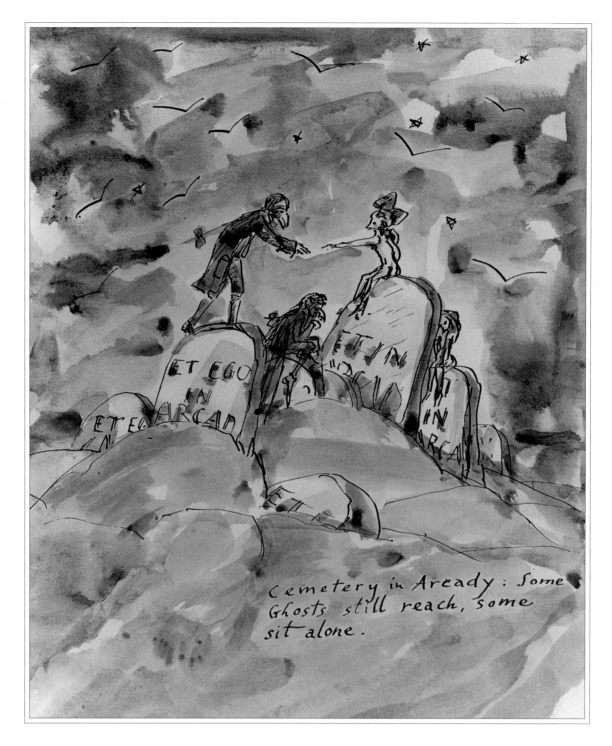

Cemetery in Arcady:
Some Ghosts Still Reach, Some Sit Alone

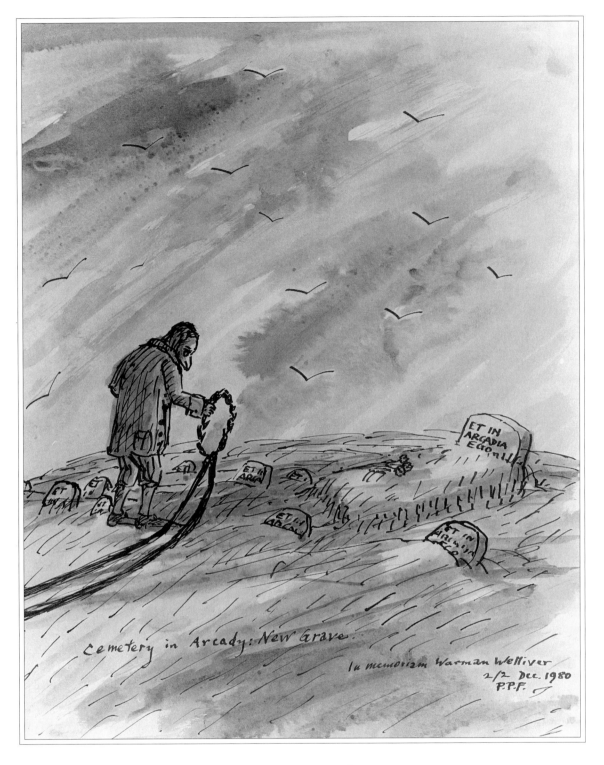

Cemetery in Arcady:
New Grave

V.
BOTTLES

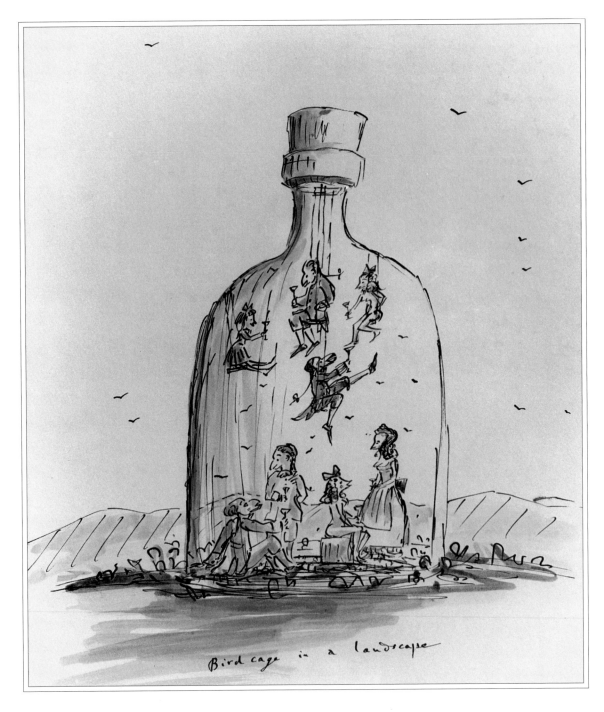

Birdcage in a Landscape

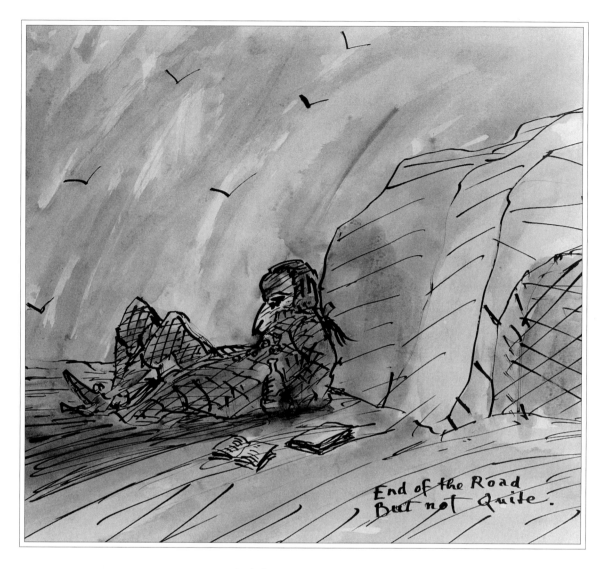

End of the Road, But Not Quite

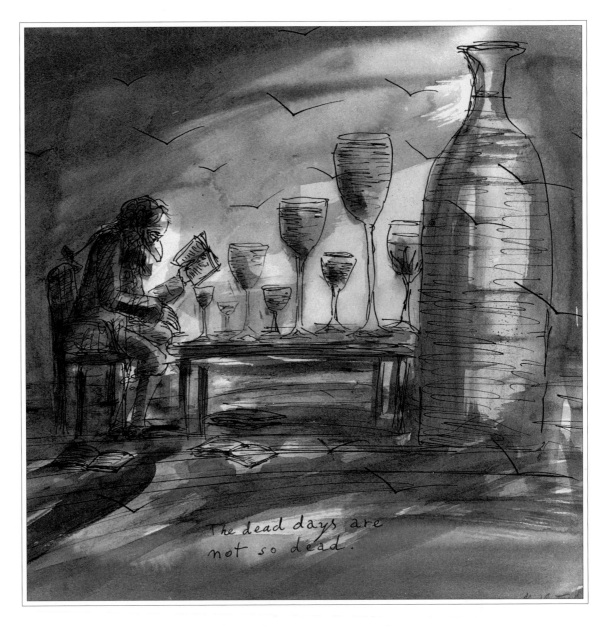

The dead days are
not so dead.

The Dead Days Are Not So Dead

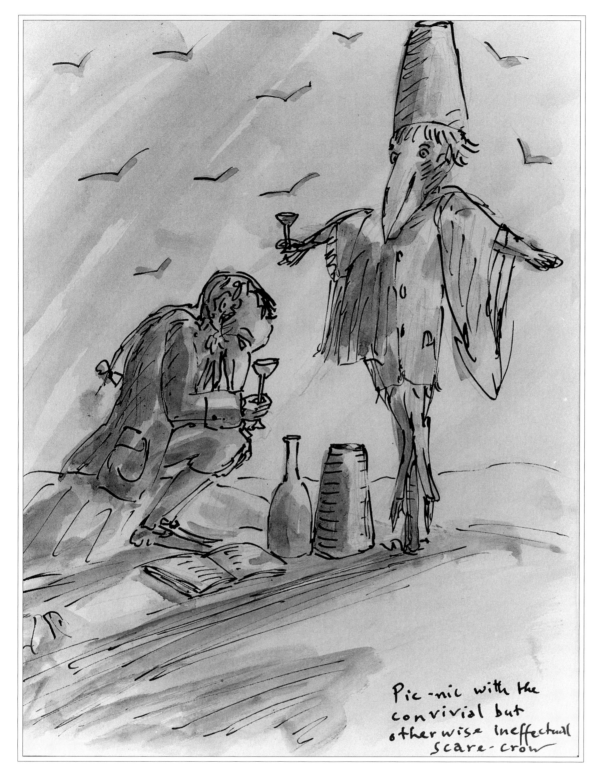

Pic-nic with the Convivial But Otherwise Ineffectual Scare-Crow

Double Vision

VI.
CIVILIZATION

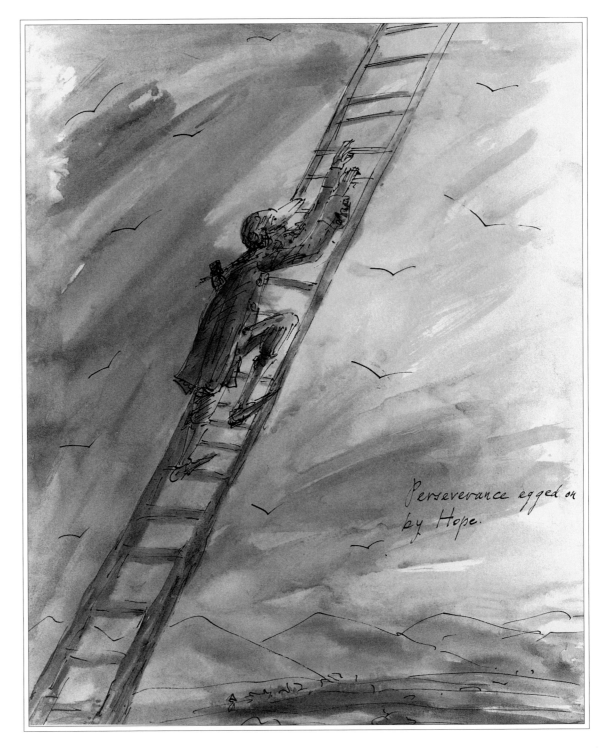

Perseverance Egged On by Hope

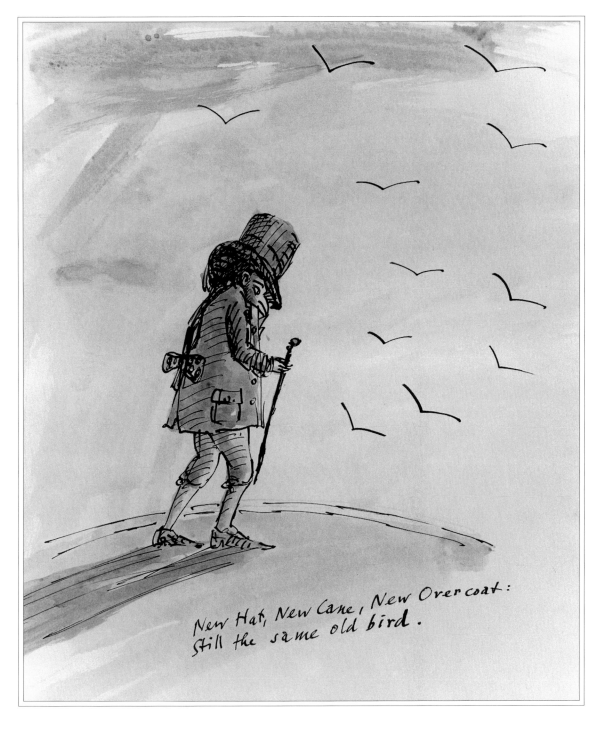

New Hat, New Cane, New Overcoat:
still the Same Old Bird

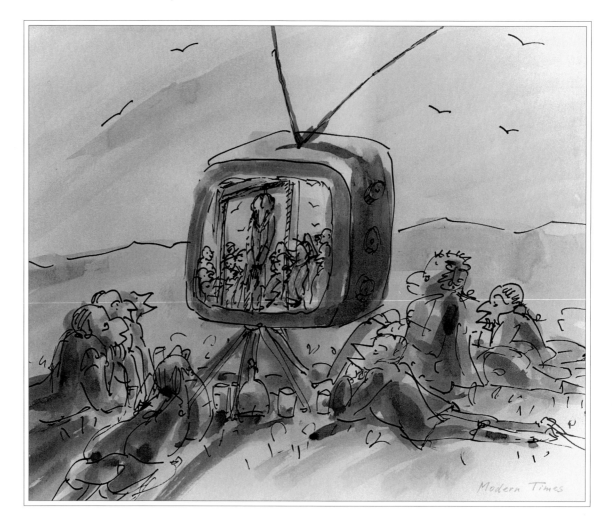

Modern Times

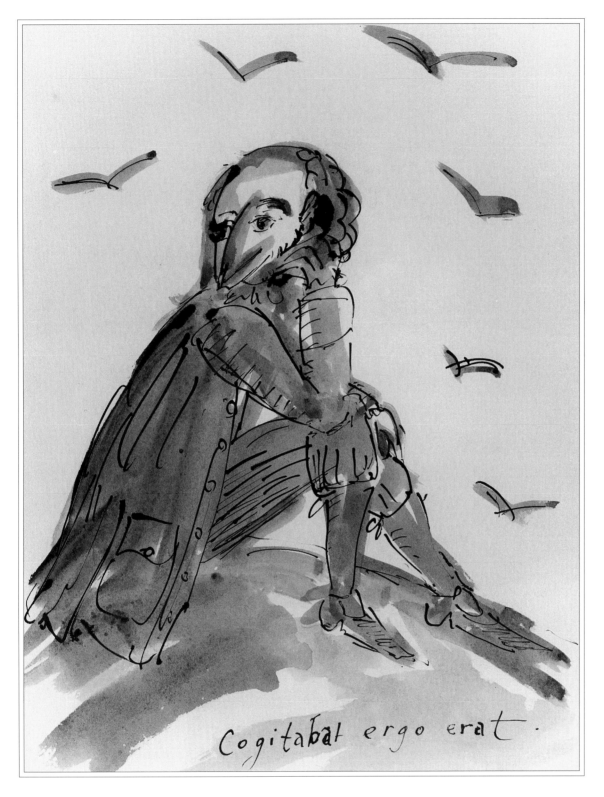

Cogitabat ergo erat

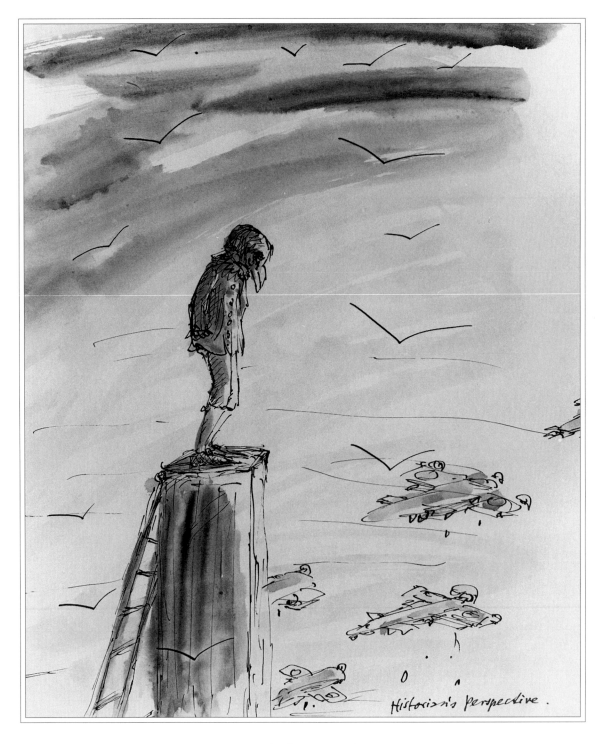

Historian's Perspective

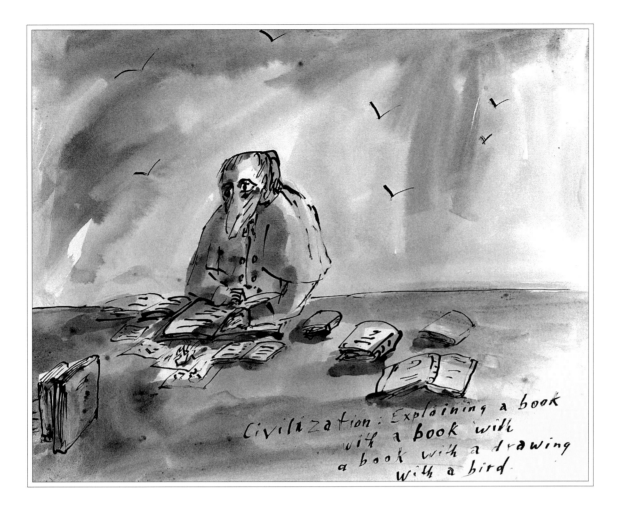

Civilization: Explaining a Book with a Book
with a Book with a Drawing with a Bird

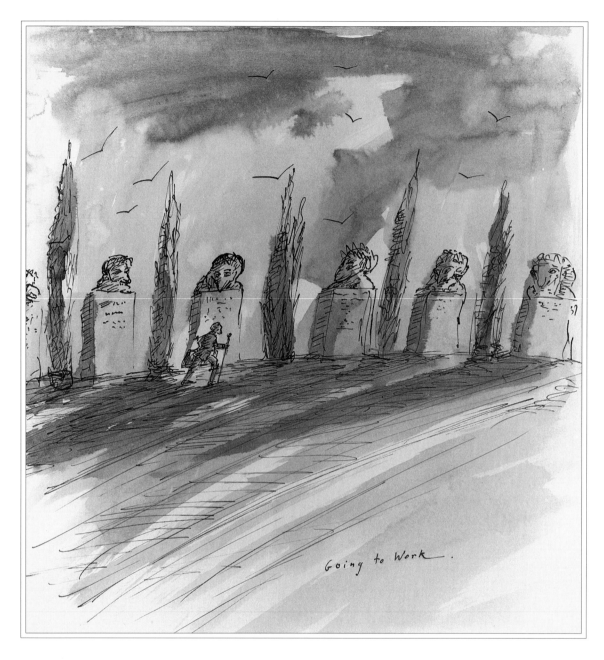

Going to Work

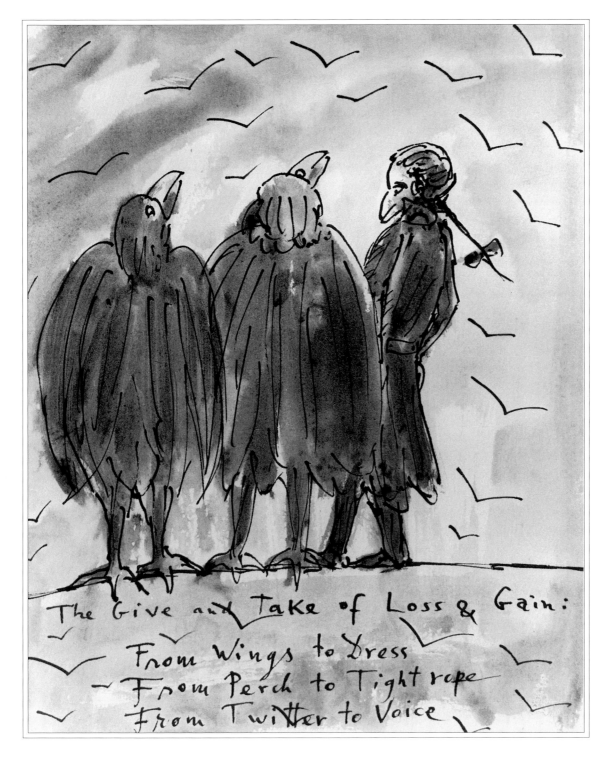

The Give and Take of Loss & Gain:
From Wings to Dress
From Perch to Tightrope
From Twitter to Voice

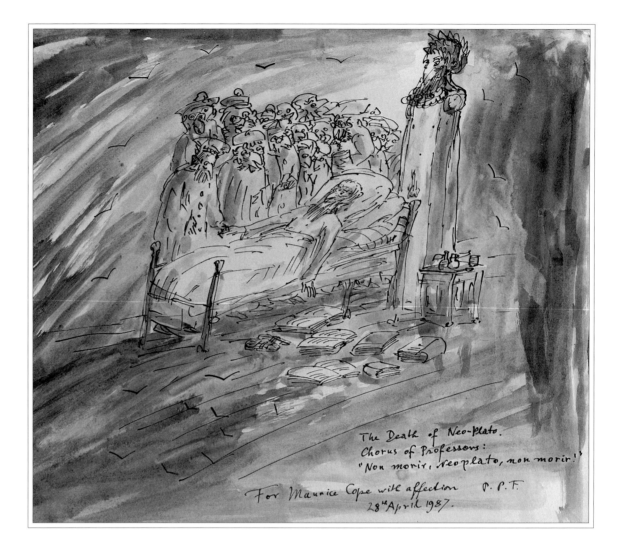

The Death of Neo-Plato
Chorus of Professors:
"Non morir, Neoplato, non morir!"

VII.
TRIBUTES

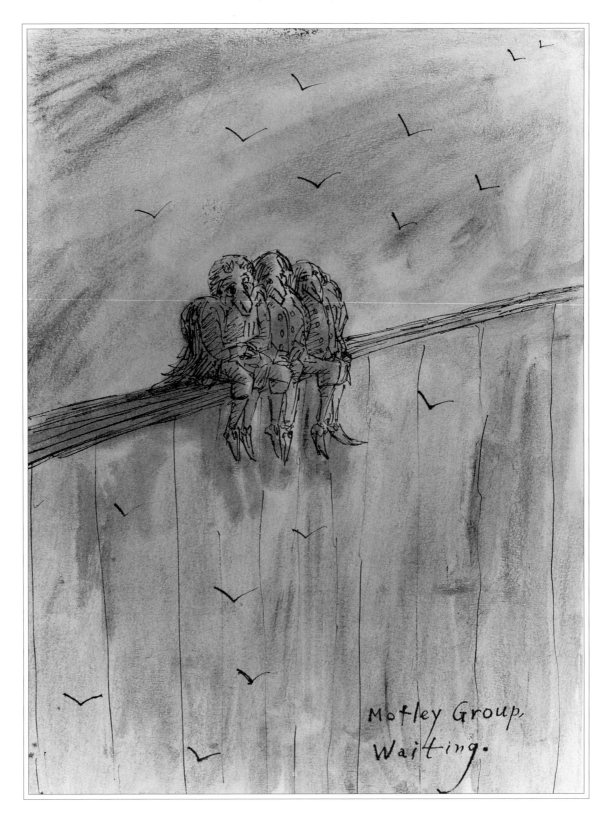

Motley Group, Waiting

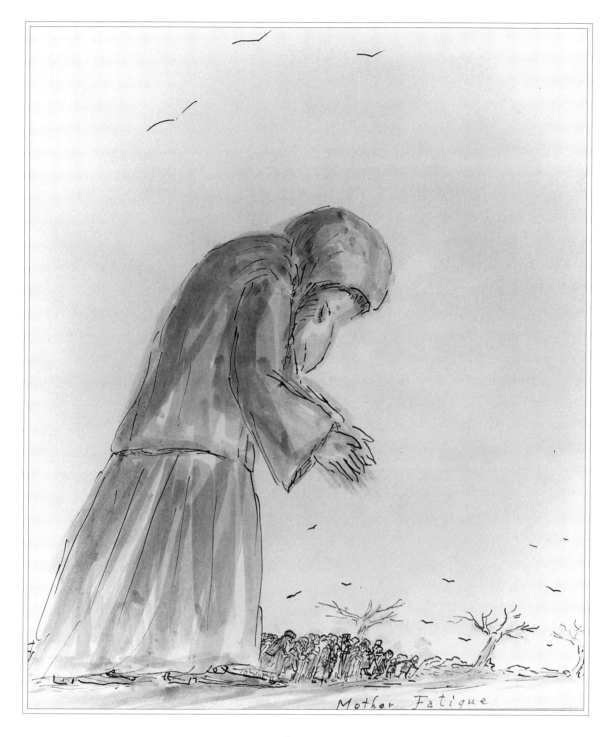

Mother Fatigue

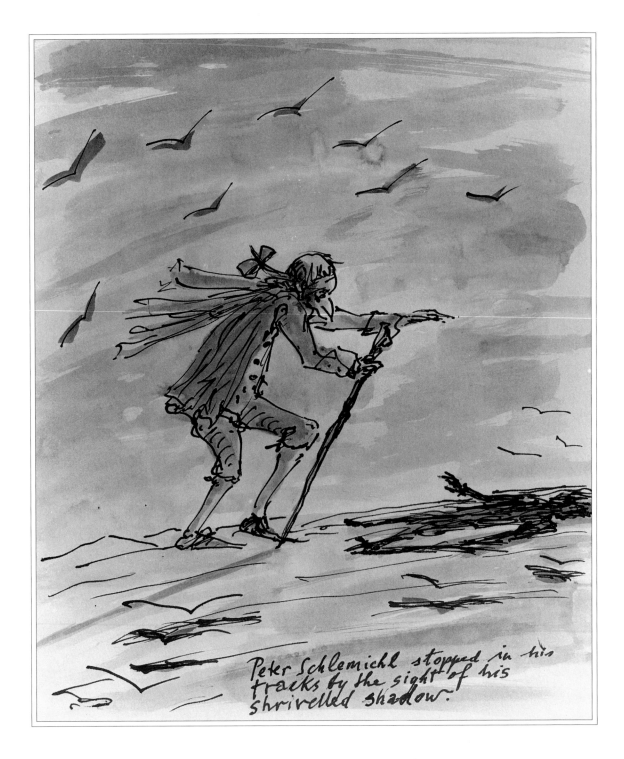

Peter Schlemiehl Stopped in His Tracks
by the Sight of His Shrivelled Shadow

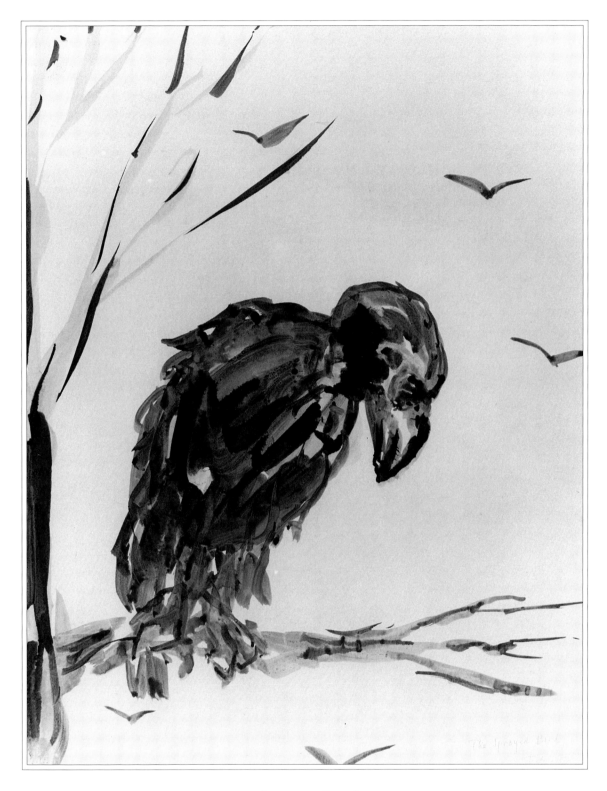

The Sprayed Bird

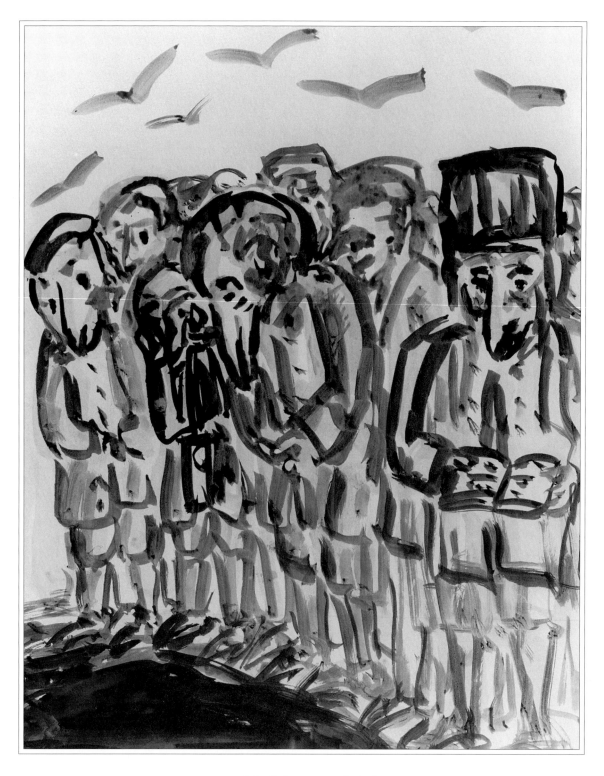

Burial of the Sprayed Bird

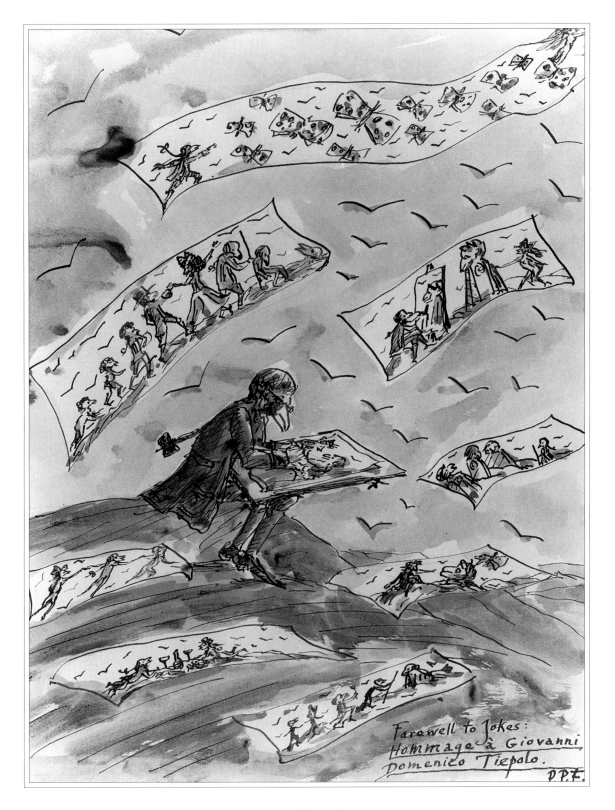

Farewell to Jokes:
Hommage à Giovanni Domenico Tiepolo

VIII.
FRIENDSHIP

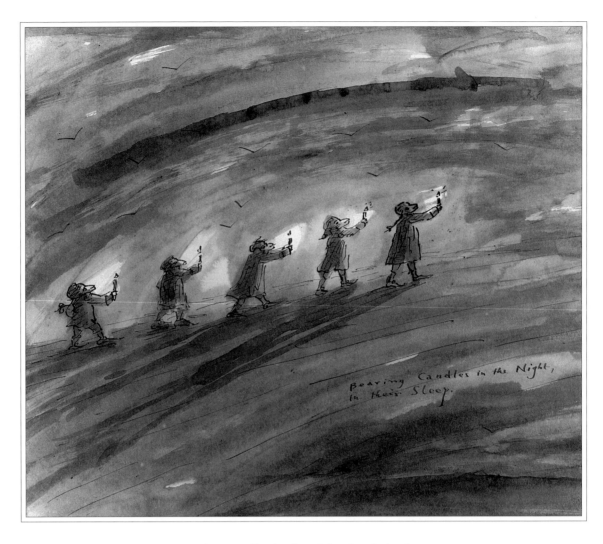

Bearing Candles in the Night, in Their Sleep

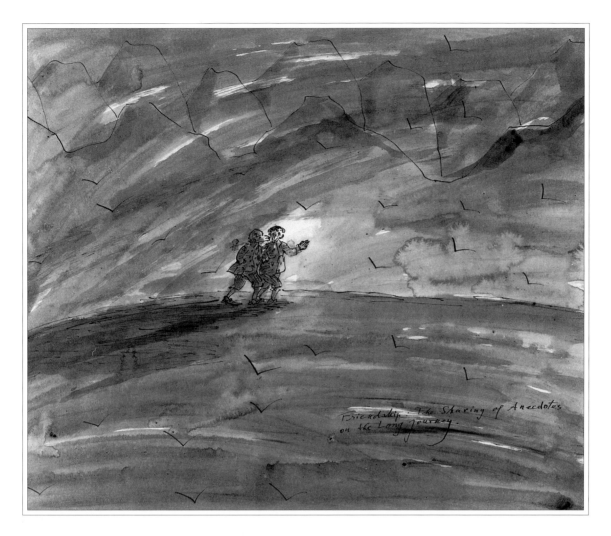

Friendship: The Sharing of Anecdotes on the Long Journey

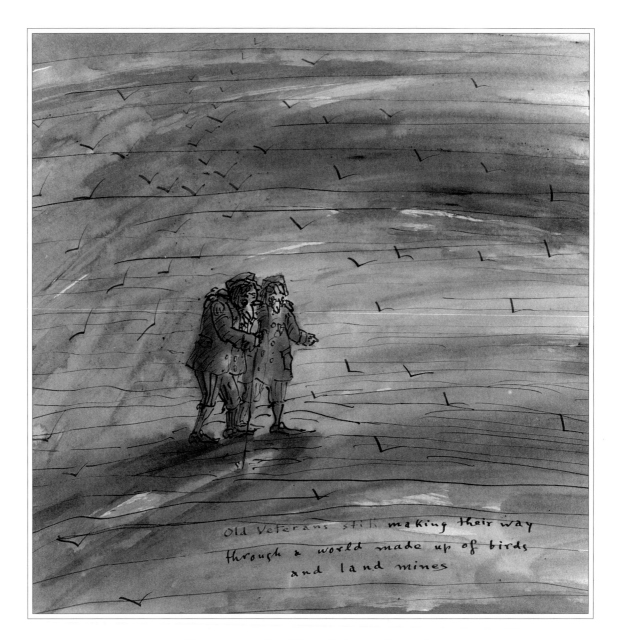

old Veterans Still Making Their Way through a
World Made up of Birds and Land Mines

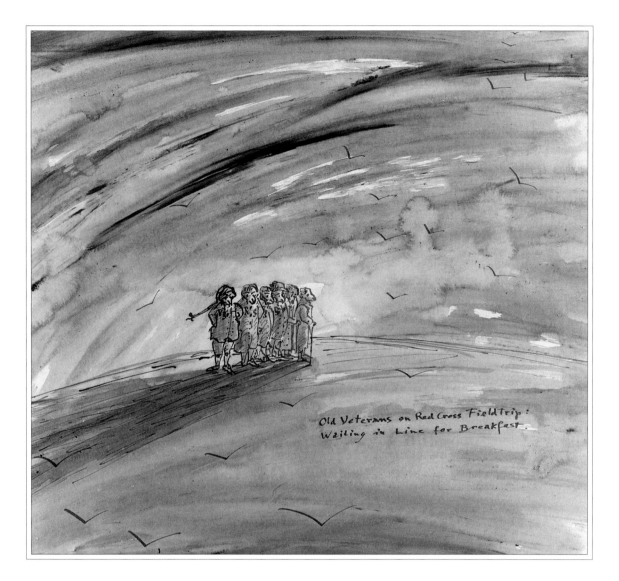

Old Veterans on Red Cross Field Trip:
Waiting in Line for Breakfast

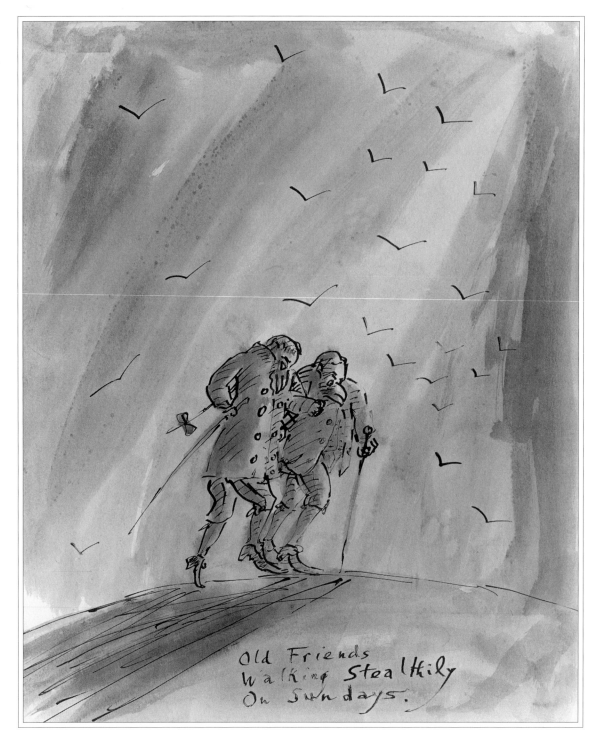

Old Friends Walking Stealthily on Sundays

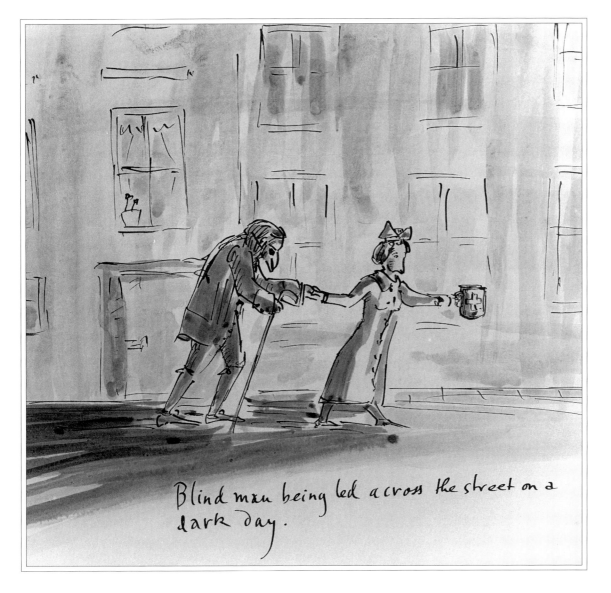

Blind Man Being Led Across the Street on a Dark Day

IX.
DREAMS OF LOVE

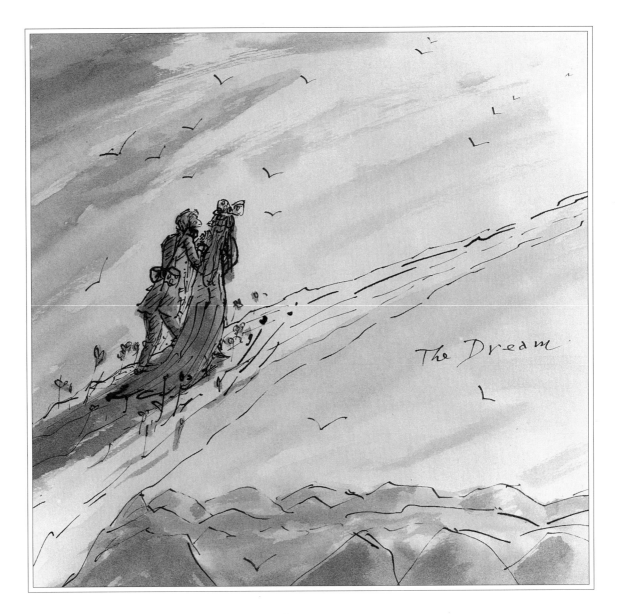

The Dream

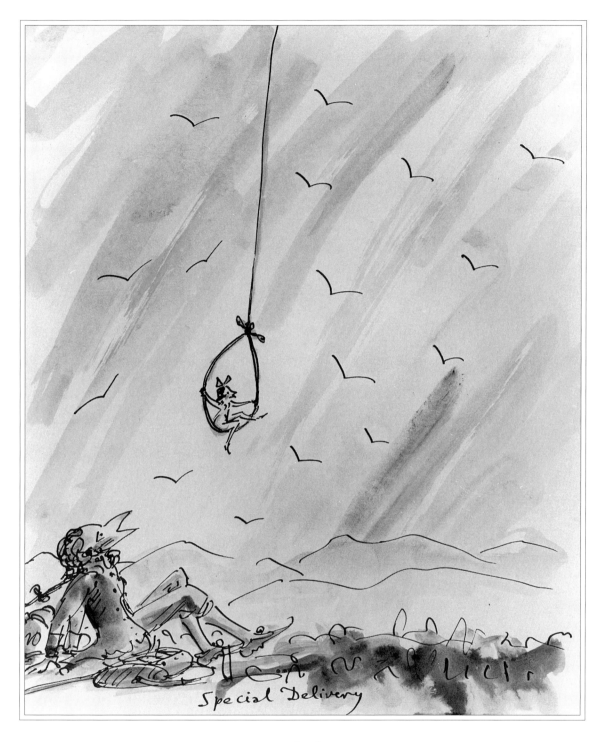

Special Delivery

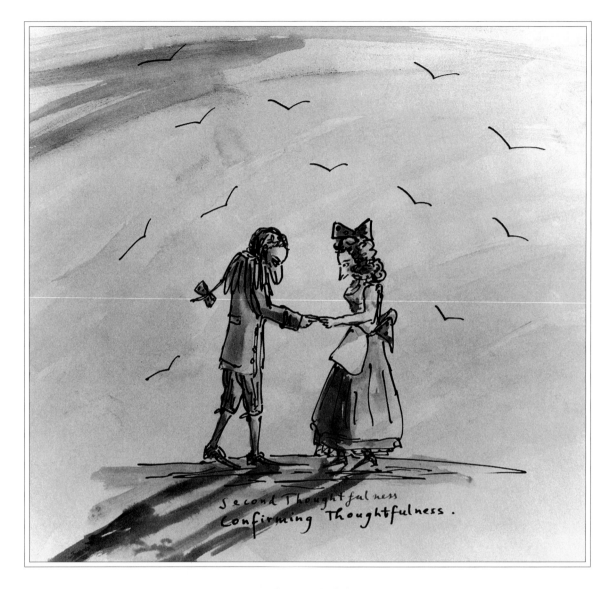

Second Thoughtfulness
Confirming Thoughtfulness

Optimist's Delight: Taking Dancing
Lessons from a Dream

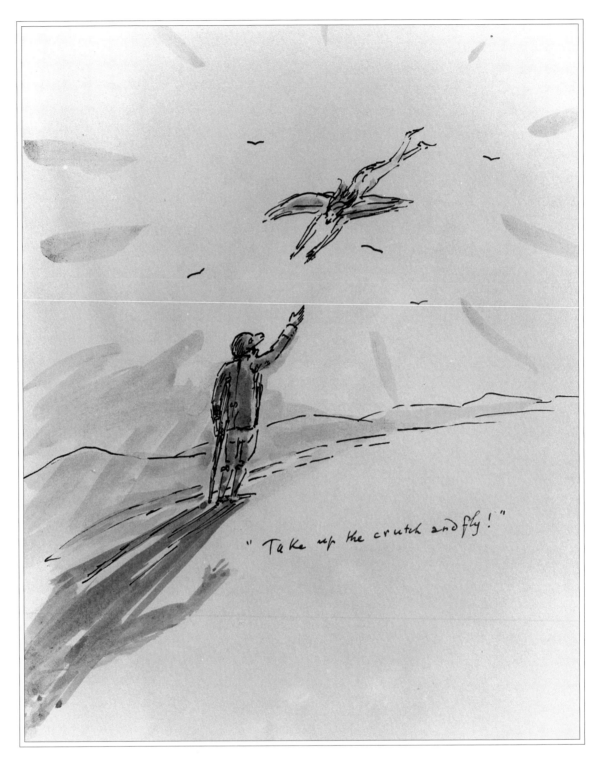

"Take up the crutch and fly!"

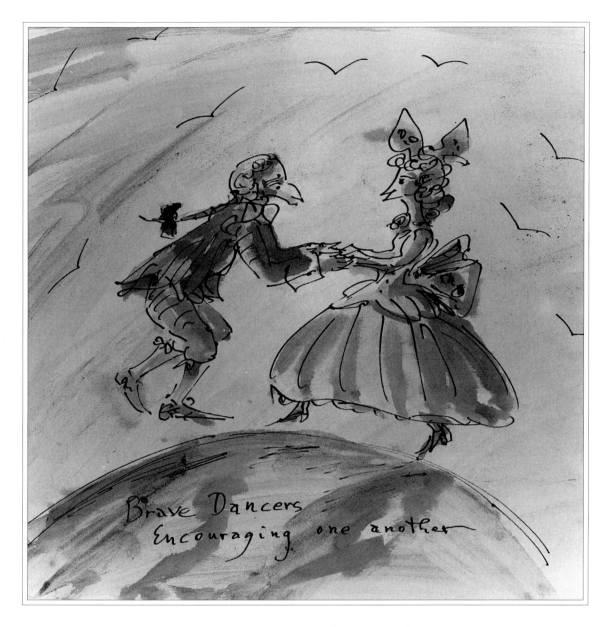

Brave Dancers Encouraging One Another

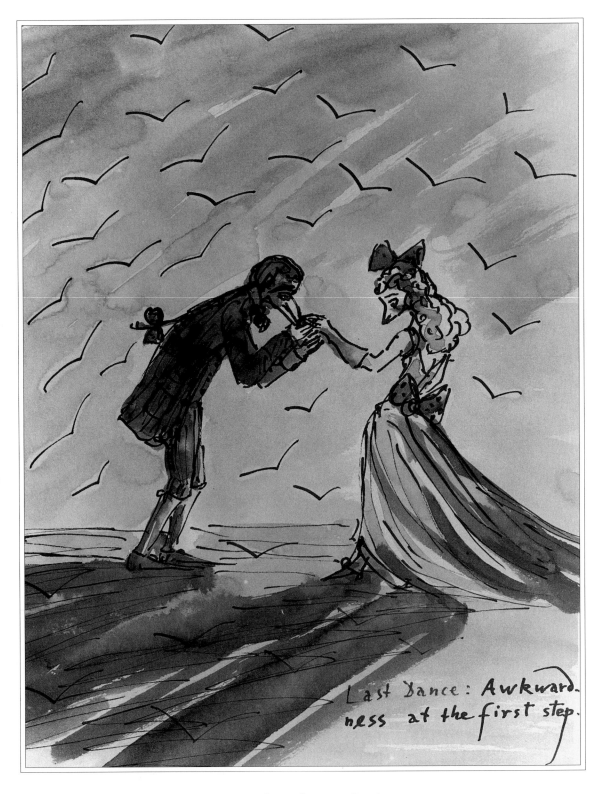

Last Dance: Awkwardness at the First Step

X.
BUTTERFLIES

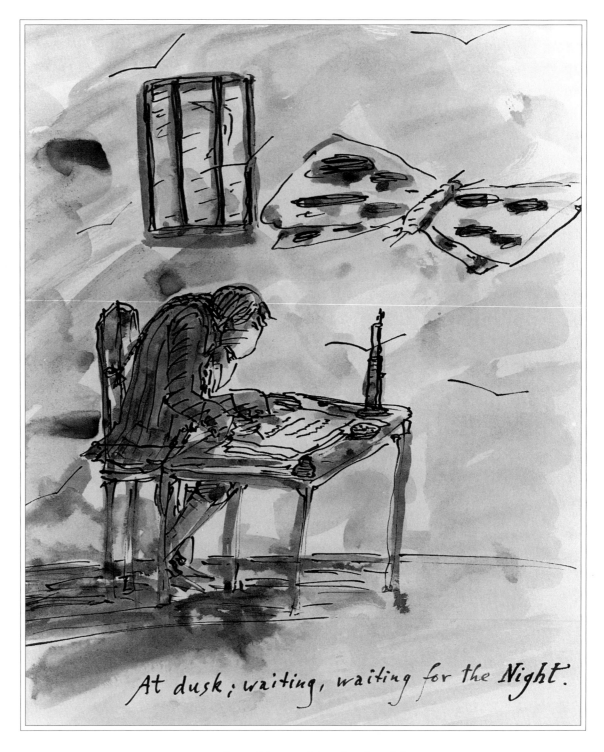

At Dusk: Waiting, Waiting for the Night

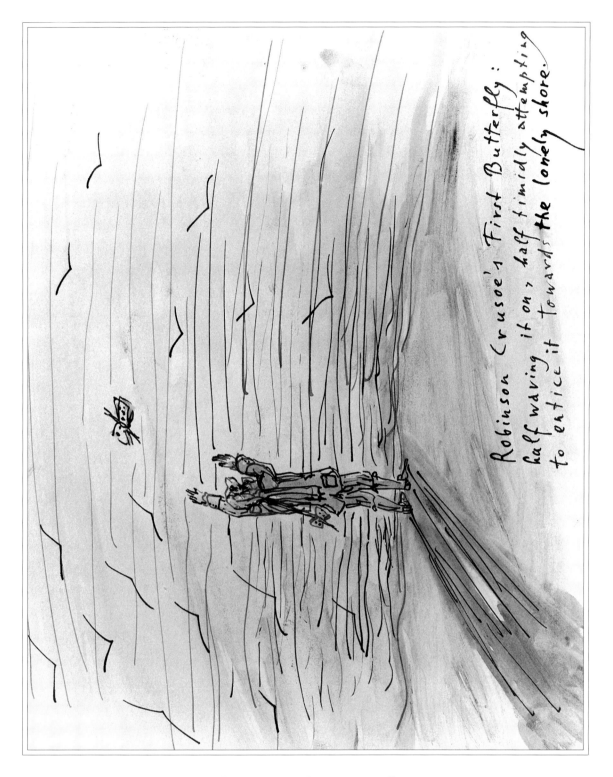

Robinson Crusoe's First Butterfly:
half waving it on, half timidly attempting
to entice it towards the lonely shore.

Robinson Crusoe's First Butterfly:
Half Waving It On, Half Timidly Attempting to Entice It
Towards the Lonely Shore

89

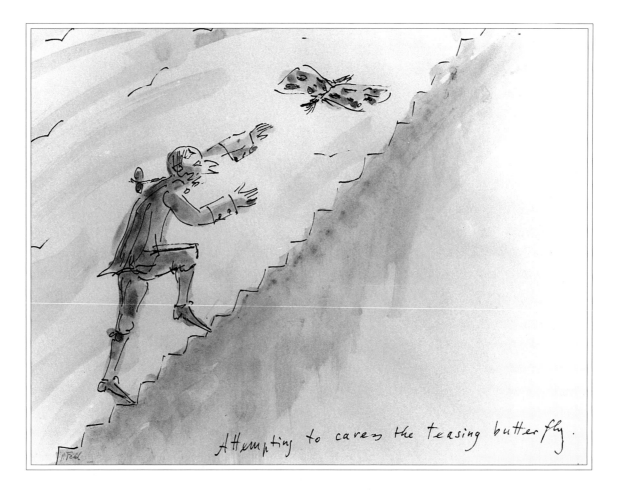

Attempting to cares the teasing butterfly.

Attempting to Caress the Teasing Butterfly

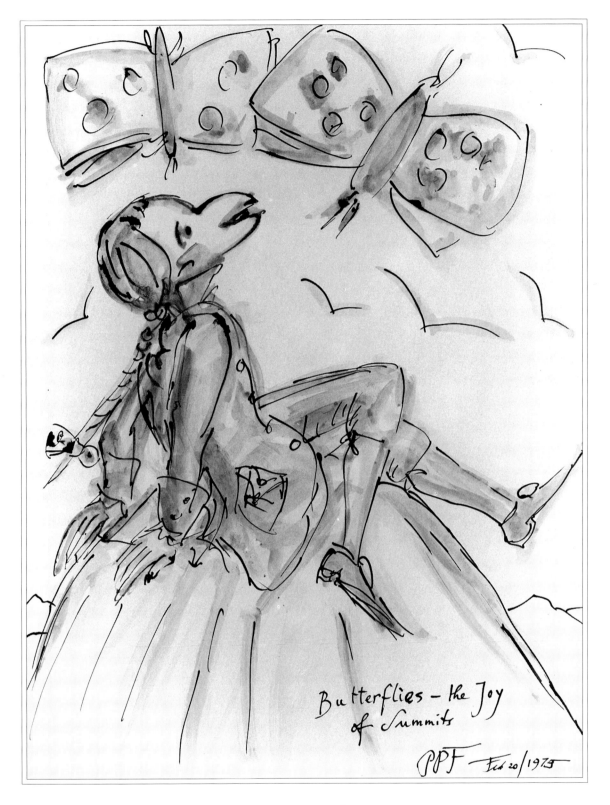

Butterflies—The Joy of Summits

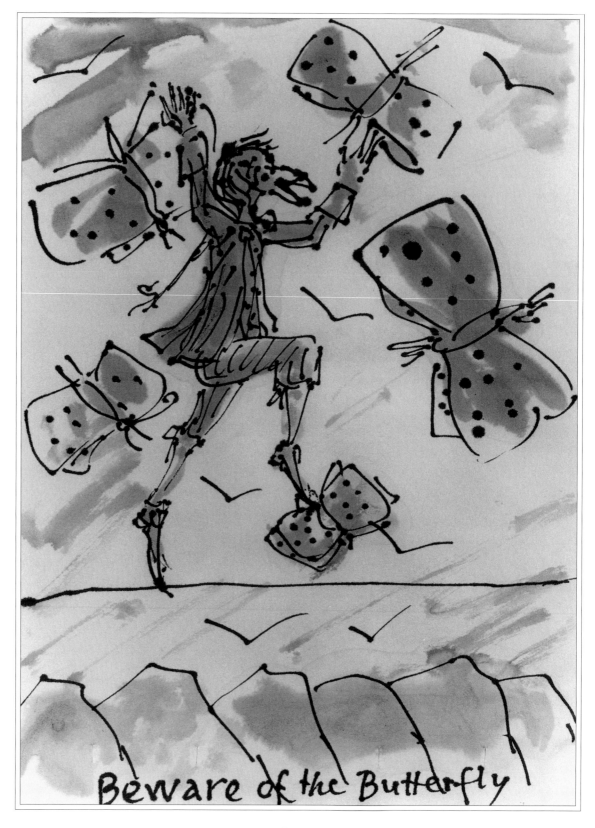

Beware of the Butterfly

XI.
UMBRELLAS

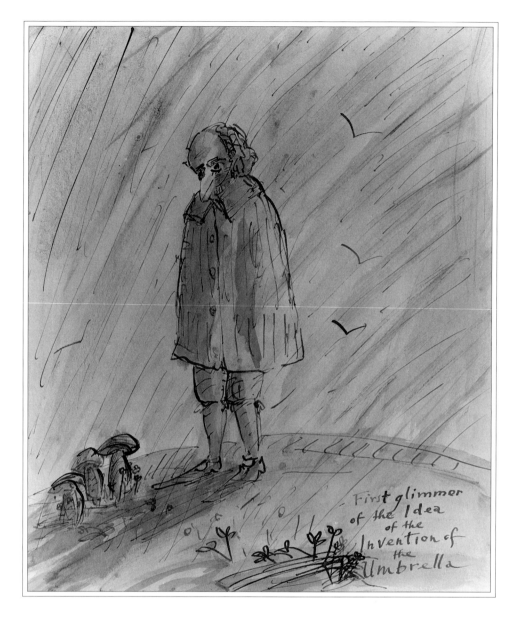

First Glimmer of the Idea of the Invention of the Umbrella

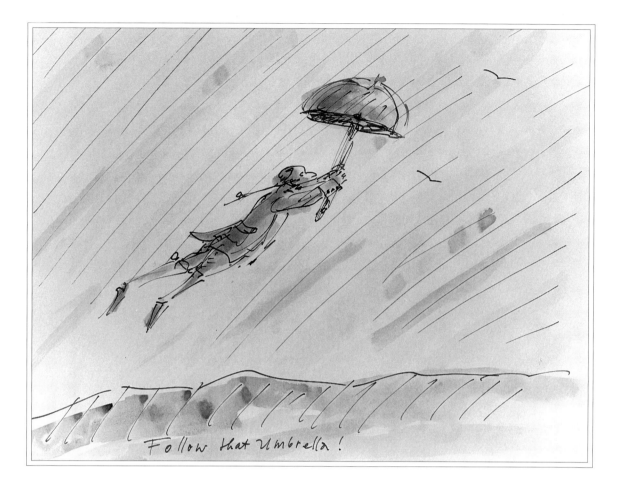

Follow That Umbrella!

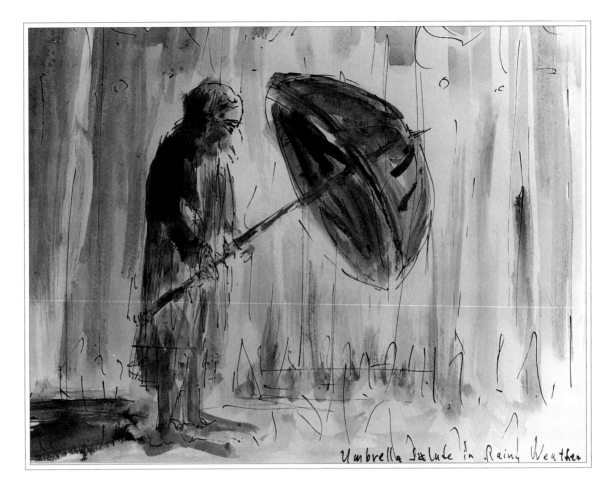

Umbrella Salute in Rainy Weather

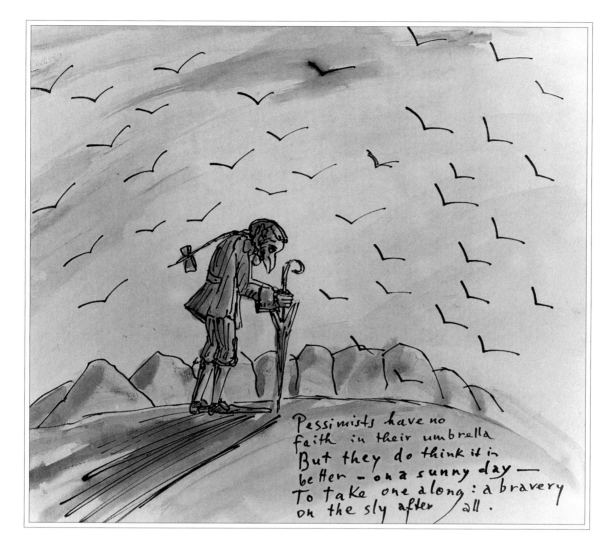

Pessimists Have No Faith in Their Umbrella,
But They Do Think It Is Better—on a Sunny Day—to Take One Along:
A Bravery on the Sly After All.

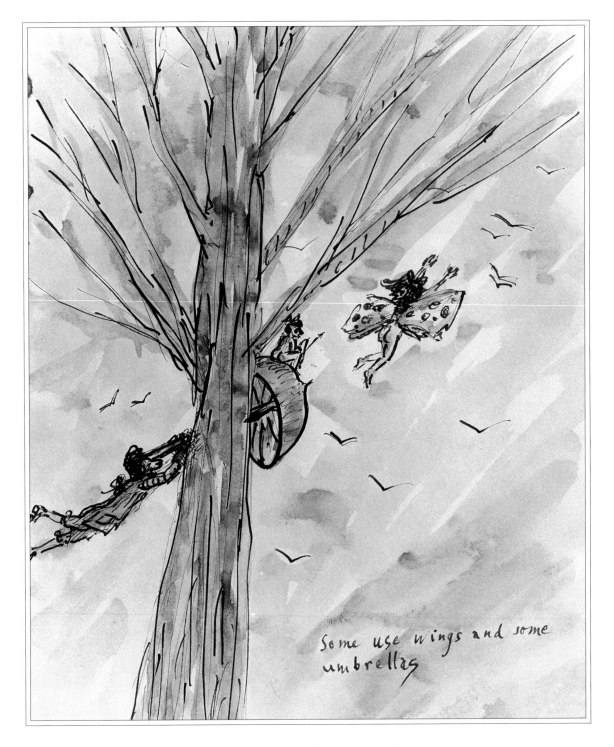

Some Use Wings and Some Umbrellas

XII.
MOLEHILLS AND MOUNTAINTOPS

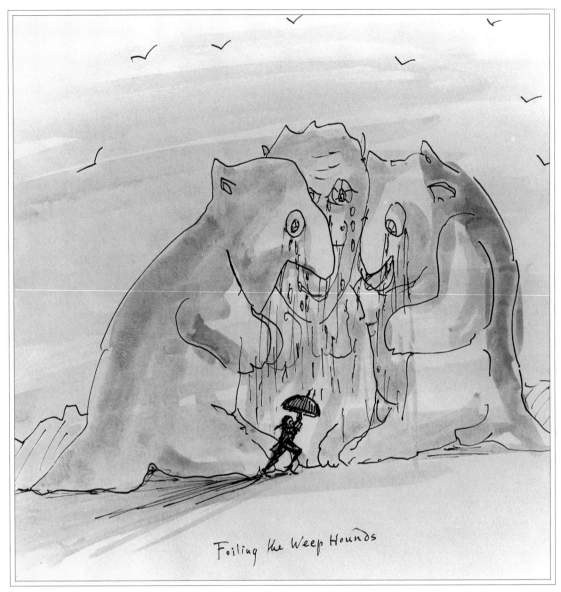

Foiling the Weep Hounds

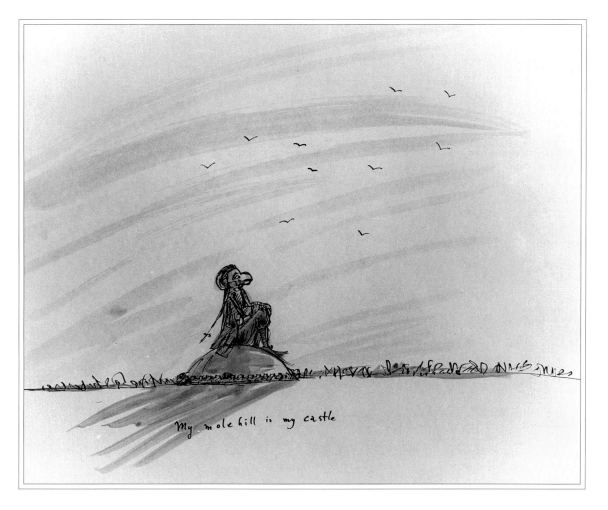

My Molehill Is My Castle

101

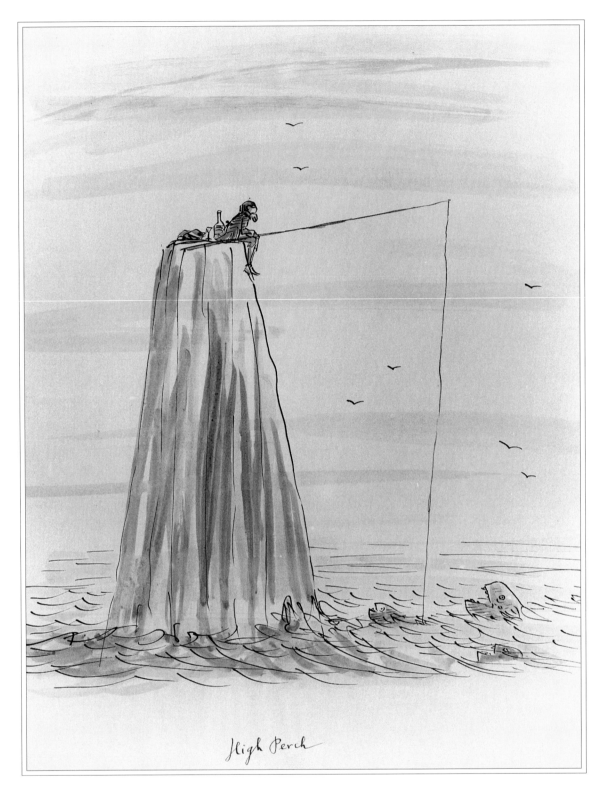

High Perch

102

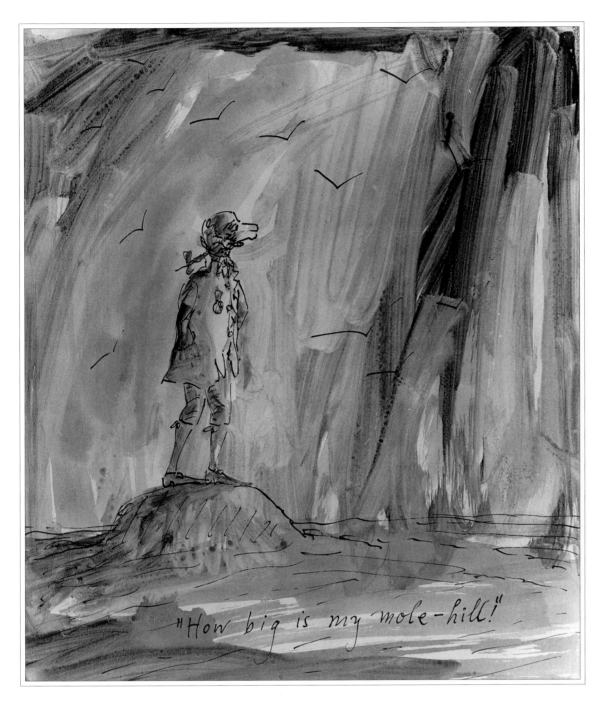

"How big is my mole-hill!"

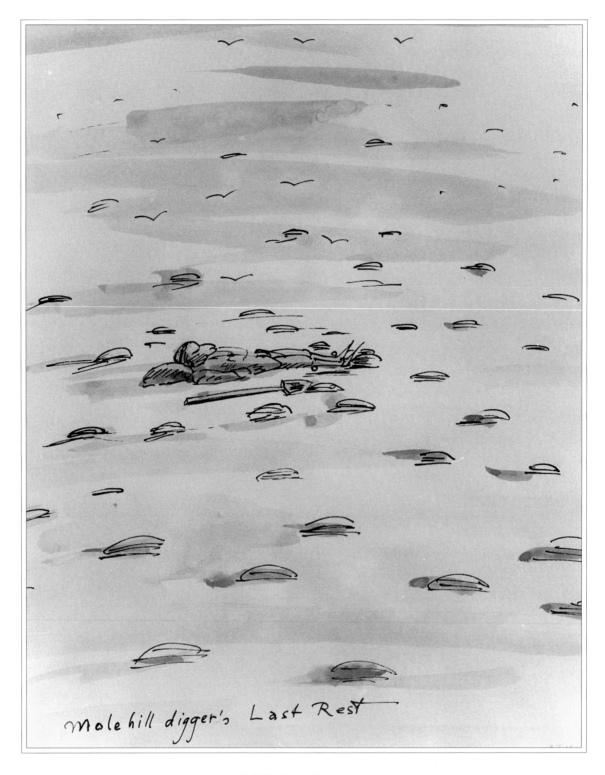

Molehill Digger's Last Rest

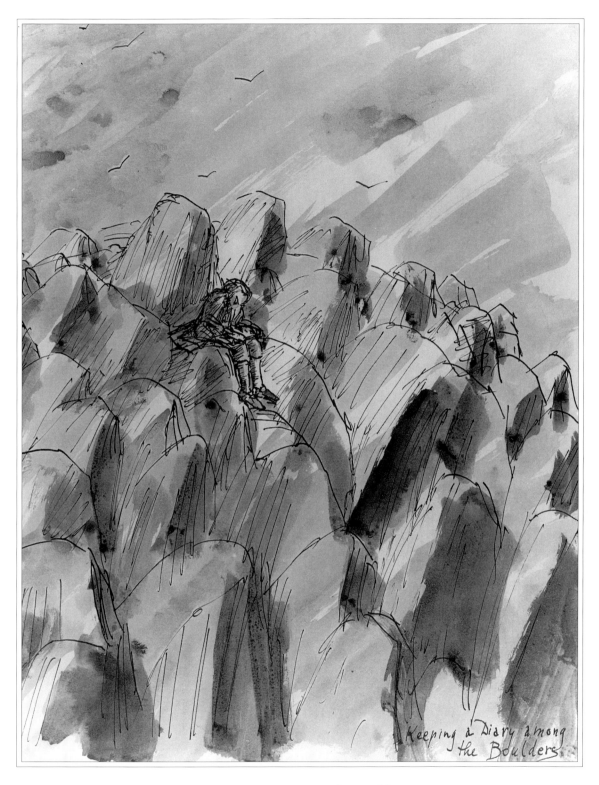

Keeping a Diary among the Boulders

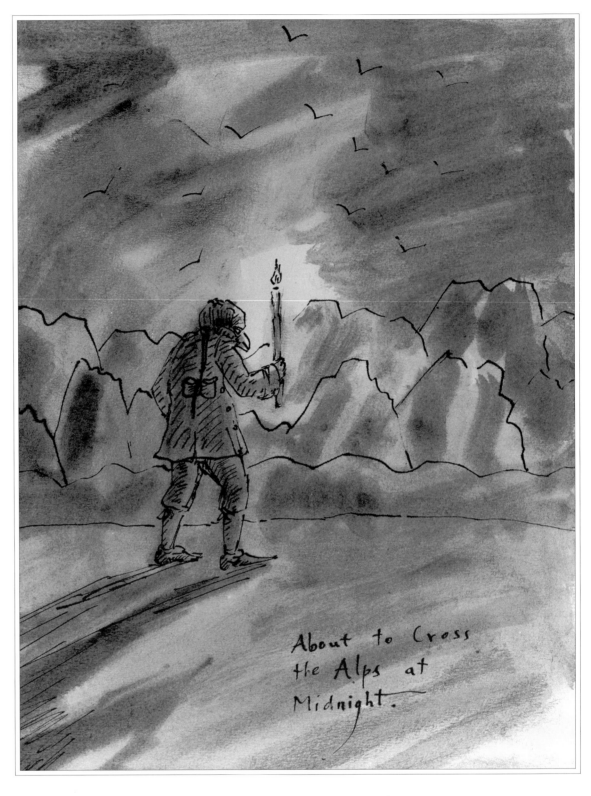

About to Cross the Alps at Midnight

XIII.
ART AND LIFE

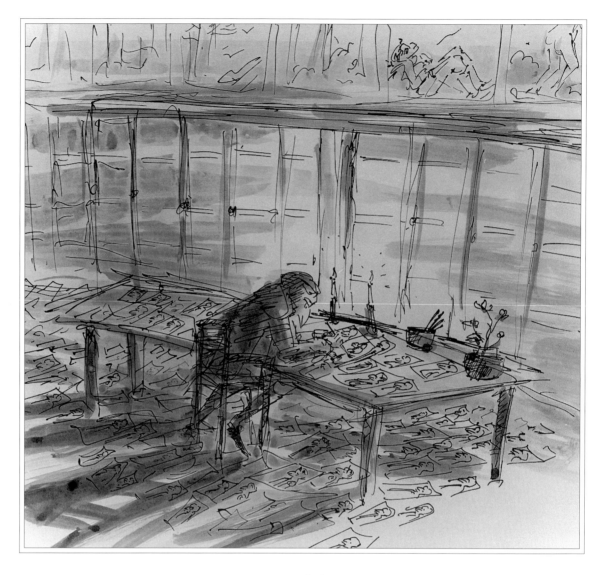

Untitled

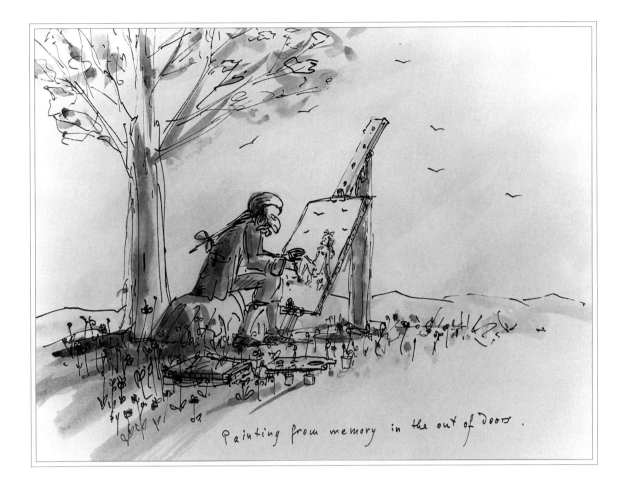

Painting from memory in the out of doors.

Painting from Memory in the Out of Doors

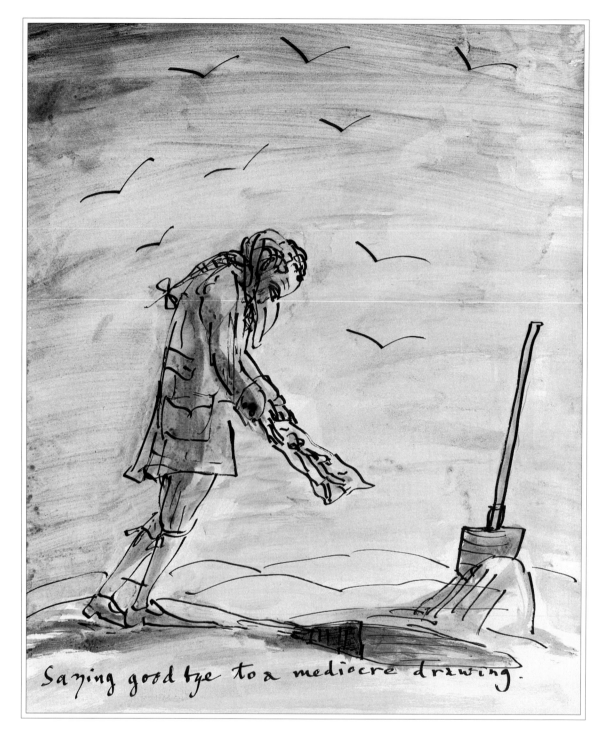

Saying good bye to a mediocre drawing.

Saying Good-bye to a Mediocre Drawing

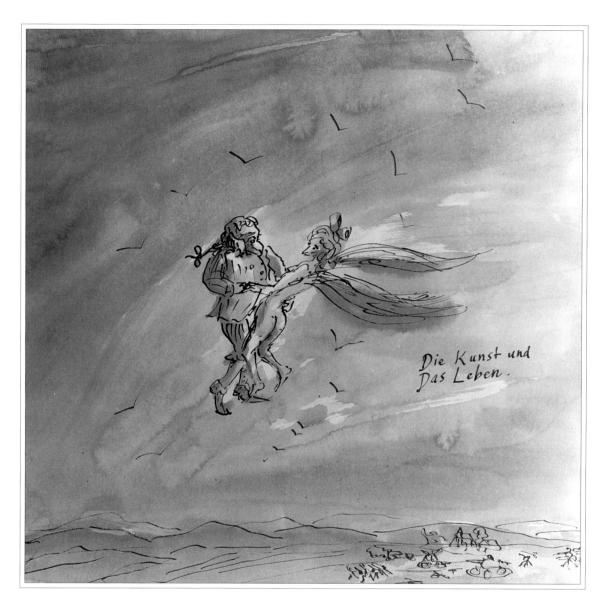

Die Kunst und Das Leben

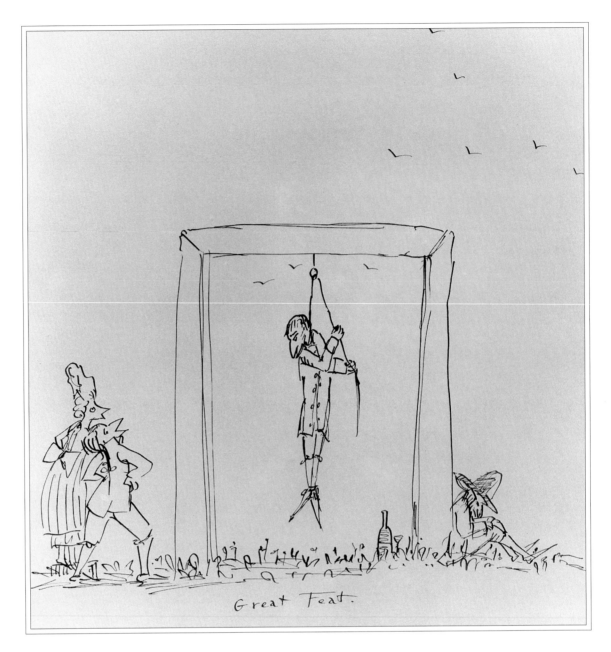

Great Feat

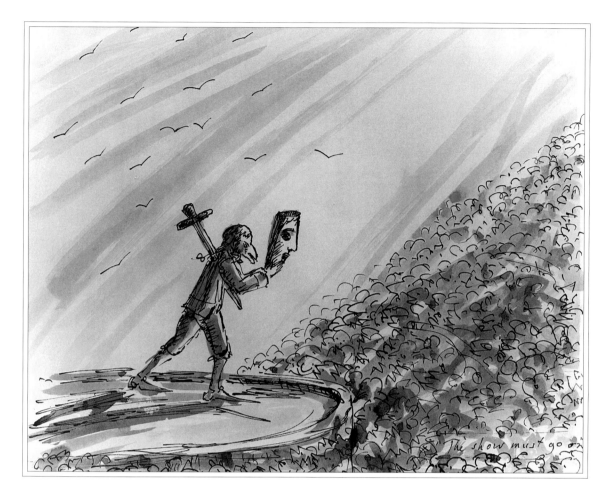

"The show must go on."

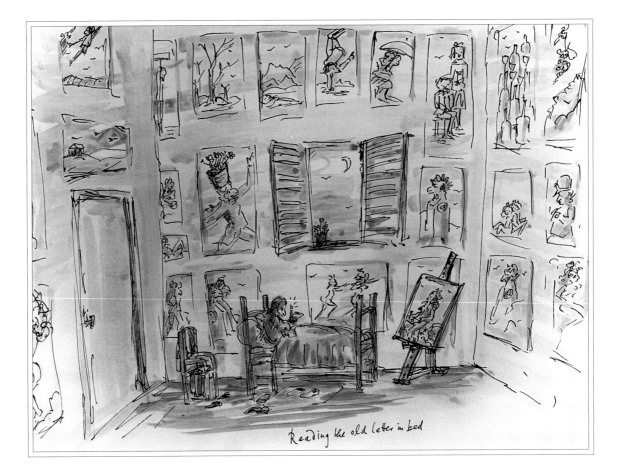

Reading the Old Letter in Bed

XIV.
BIRDS OF A FEATHER

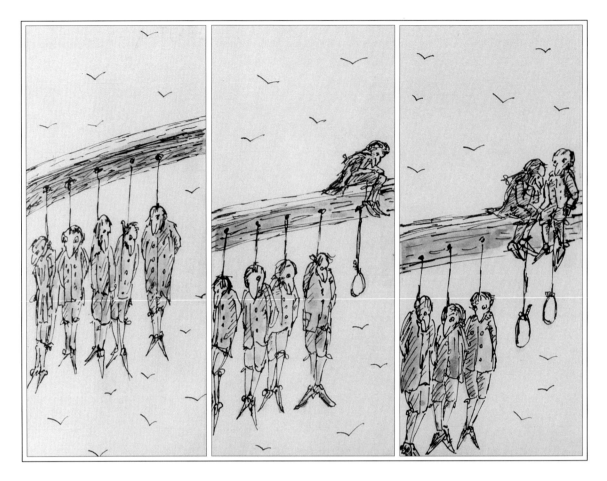

Birds of a Feather

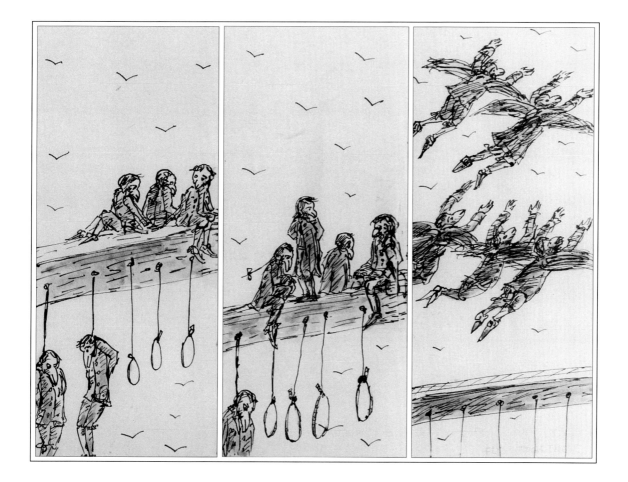

University of Illinois